Historic Engl

Hull

Paul Chrystal

AMBERLEY

About the Author

Paul Chrystal is a publisher, author of around 100 books, and a broadcaster. He has appeared regularly on BBC local radio – York, Manchester and Tees – on the BBC World Service and on the PM programme. He writes features and book reviews for national newspapers and history magazines His books cover a wide range of subjects from local and social history to classical history. Recent titles include *In Bed with the Romans*, *Women in Ancient Greece*, *Women at War in Ancient Greece & Rome*, *Coffee: A Drink for the Devil*, and *Roman Military Disasters*.

By the same author:
Hull in 50 Buildings
Hull Pubs (in press)
Pocklington Through Time
Historic England: York
Historic England: Leeds
York: The Postcard Collection
York in the 1970s

For a full list, please visit www.paulchrystal.com.

First published 2017

Amberley Publishing
The Hill, Stroud, Gloucestershire, GL5 4EP
www.amberley-books.com

The images on the following pages are owned by the author: 4, 6 (below), 18 (below), 55 (below), 56, 58 (below), 61 (below)m 62 (below)m 63 (below), 64 (below), 81, 83, 84 (below), 93 (above), 95 (below).

The images on the following pages have been reproduced by permission of Historic England Archive: 6 (above), 7 (above), 11, 12 (above), 13 (below), 14, 15, 16, 17, 41, 45, 46, 67, 68, 69, 71, 72, 73, 88, 89 (above), 94 (below), 95 (above).

The lower image on page 7 is courtesy of Steve West and Gordon Stephenson at Reckitt Benckiser Heritage, Hull.

The images on the following pages are © Crown copyright. Historic England Archive: 42 (above), 43, 44, 47, 48, 49, 50, 51, 52, 64 (above), 65, 66, 93 (below), 94 (above).

ISBN 978 1 4456 7534 3 (print)
ISBN 978 1 4456 7535 0 (ebook)

British Library Cataloguing in Publication Data.
A catalogue record for this book is available from the British Library.

Origination by Amberley Publishing.
Printed in Great Britain.

Contents

Hull – 2017 City of Culture

Hull was named 2017 City of Culture on 21 November 2013. The award is given every four years to a city that demonstrates the belief in the transformational power of culture. In Hull, the year 2017 has been split into four seasons, with each celebrating a different aspect of Hull's history and culture. This new book, with its rarely seen images from Historic England's archive, celebrates the city's status as one of the north's leading cultural places.

In January 2017 a truly unique structure came to Queen Victoria Square, as a gift from Siemens, to form part of Hull's role as UK City of Culture. Transporting the huge wind turbine blade from the Siemens Alexandra Dock factory to the city centre was a massive logistical exercise. The blade was mounted 5.5 metres from the ground at its highest point, allowing buses to pass underneath. On March 18 2017 it returned to the Siemens site on Alexandra Dock.

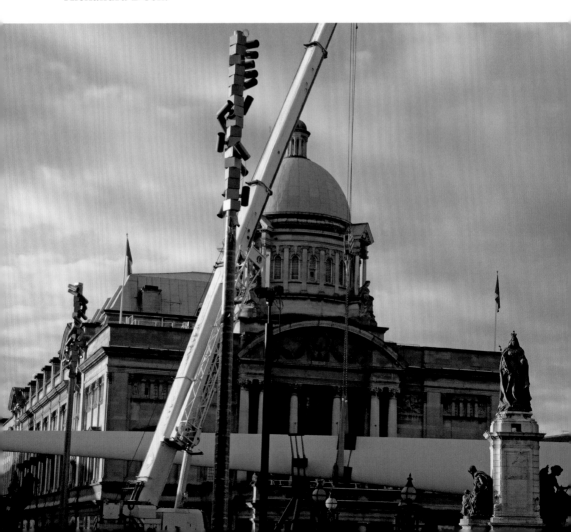

Introduction

There are many books on the history and buildings of the city of Hull, which is not surprising given the rich heritage and history that characterises the city. This book, however, is different from all the others because it benefits from having access to a magnificent archive: most of the images come from the picture archive of Historic England – a marvellous repository of photographs of England.

The result is a book full of images that have rarely been seen before now. While many of the places depicted are familiar, the images in these pages show a different, refreshing take on them; the city of Hull is seen here in a very different light. We have a unique view inside HMP Hull; we go to the park, the baths and the pictures; we revisit the terrors of the Blitz; and we tour the socially inspired Reckitt Garden Village, all within these ninety-six pages.

At the same time as making this journey we chart the history of Hull through its buildings. We see its vibrant marketplace, and long-since gone major department stores; its modernised and beautified docks, and its redundant fishing industry; its prefabs and its low-rise living; its beautiful churches; its grand old cinemas and glorious Victorian swimming pools; its world-class university; and, of course, its pubs – the best of which evoke the days when fish and ships were the lifeblood of this great city of culture.

The Hull Blitz

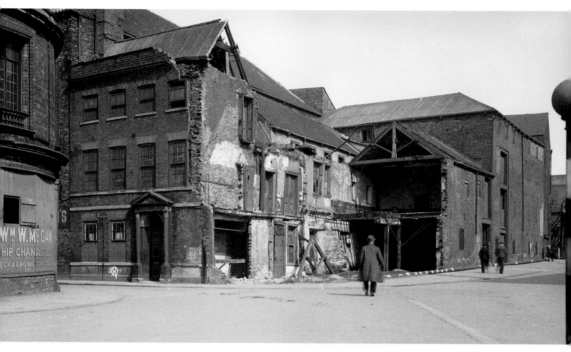

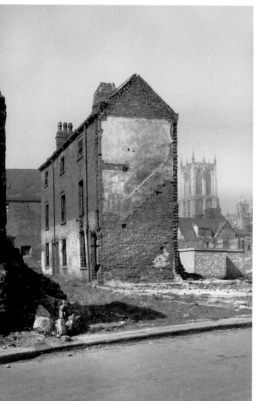

Above: No. 9 High Street
The remains of the bomb-damaged warehouse at No. 9 High Street in 1945. In terms of damaged or destroyed housing stock, Hull was the most severely damaged British city or town during the Second World War, with 95 per cent of houses damaged. The people of Hull lived under air-raid alert for 1,000 hours. Hull has the unfortunate privilege of being the target of the first daylight raid of the war and the last piloted air raid on Britain.

Left: High Street
Bomb-damaged houses in 1945 on the High Street, with Holy Trinity Church in the background. The houses stood on the west side of the street, near Grimsby Lane.

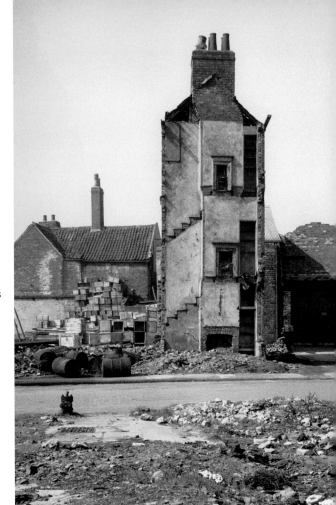

Right: High Street
The remains of a bombed house on the High Street, showing the fireplaces on each of the three floors. The house is believed to have stood near to Grimsby Lane.

Below: Bomb Damage in the Reckitt Garden Village
Thirty-one-year-old Eddie Morton was in bed above his grocer's shop on the night of 18 August 1941 when an air raid started; a bomb exploded on his shop, blowing him into Beech Avenue – still in his bed.

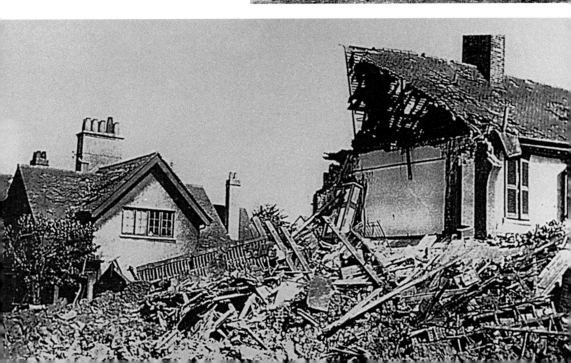

The Reckitt Garden Village

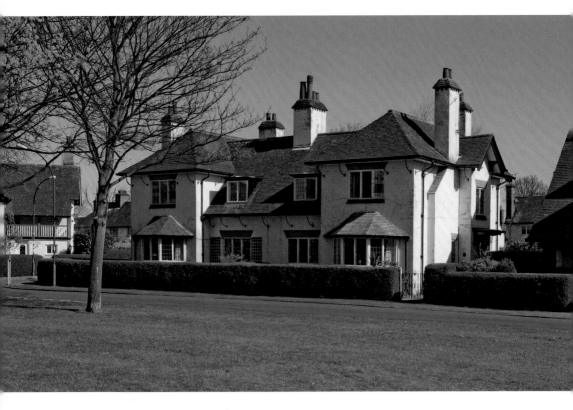

The Garden Village

The Garden Village was the realisation in 1908 of Quaker Sir James Reckitt's wish to improve the domestic and social circumstances of the workers at his household products, disinfectants and pharmaceuticals factory in Dansom Lane. The estate is comprised of around 600 houses on 130 acres with a population of just over 3,000. To avoid overcrowding there was a maximum of twelve houses per acre of land, with each house taking up 500 yards – estimated as worth 2s in garden produce to the tenant. First-class houses came with a bathroom along with both an outdoor and upstairs toilet, while the second-class houses had the bath in the scullery under a lift-up tabletop and one outdoor toilet. All houses had a black stove in the kitchen, which heated the oven and the hot water. They had gas lighting and some houses had a telephone connected. The first-class houses had brass door knobs. There was a bell at the front and back door and in the main rooms so that when someone rang the bell, the room they were in was indicated on a panel in the kitchen.

The image above shows The Oval, Garden Village, in 2010.

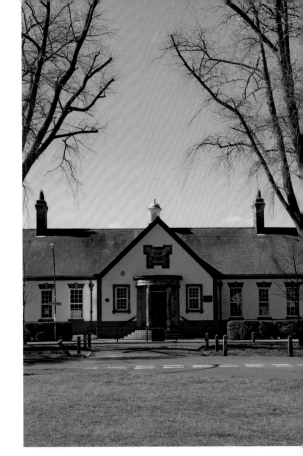

Right: Humberside Police Boys Club, Elm Avenue, in the Garden Village in 2010.

Below: This photo shows the Garden Village Shopping Centre, Beech Avenue.

Hull Parks

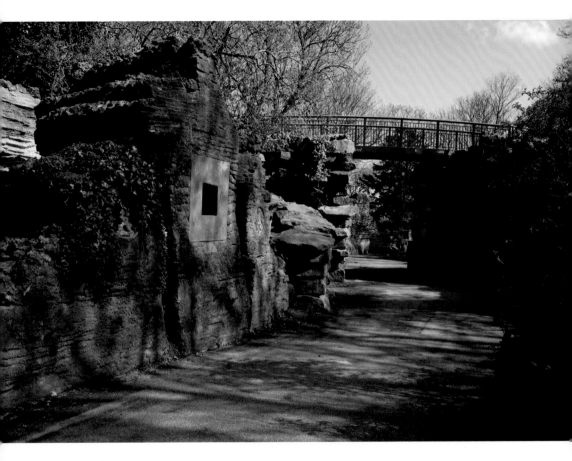

East Park

This image from 2010 is looking along the path through East Park's 'Khyber Pass' rock feature in Holderness Road. It is the largest public park in Hull and opened to the public on 21 June 1887 – Queen Victoria's Golden Jubilee. Attractions include a giant walk-through aviary, a wildlife education centre, a boathouse, and a community pavilion. The Victorian Khyber Pass, Wicksteed Splash boat, original maze, and the Valley Ornamental Gardens have recently been restored.

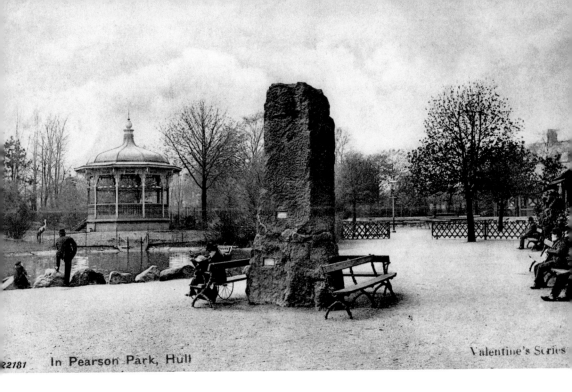

In Pearson Park, Hull Valentine's Series

Pearson Park

Above: Pearson Park around 1900, showing the standing stone. Pearson Park lies between Princes Avenue and Beverley Road and it 'still resonates with Victorian grandeur'. Philip Larkin lived in No. 32 overlooking Pearson Park from 1956–74. Originally known as the People's Park, it was Hull's first public park. The land was gifted by Zachariah Charles Pearson (1821–91) to mark his first term as Hull's mayor.

Below: Looking towards the ruins in Pearson Park.

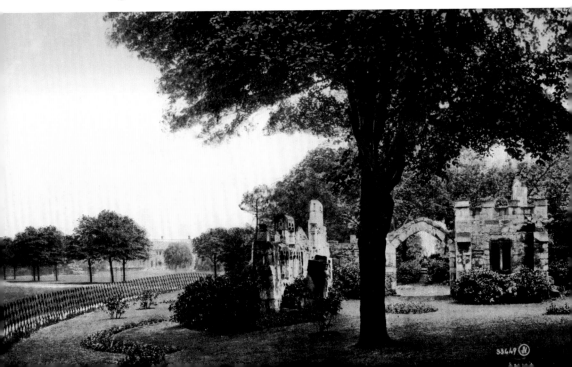

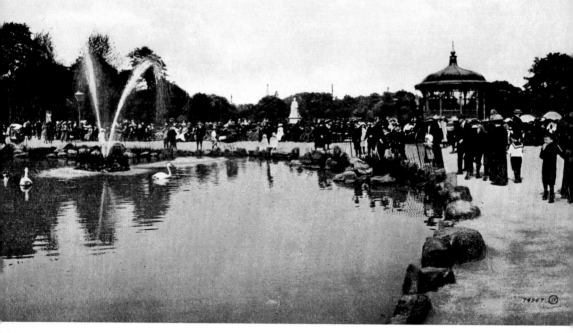

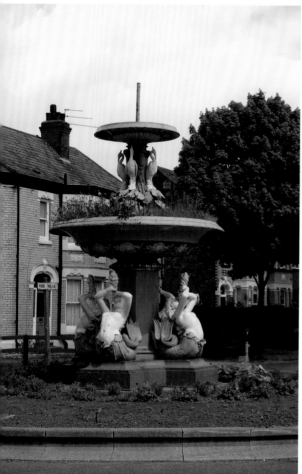

Above: Pearson Park
Looking towards the lake in Pearson Park around 1910. Features of the park include a serpentine lake, a carriage drive running around the perimeter, and a Victorian conservatory, which was rebuilt in 1930. In 1864 the park could boast a cricket ground, a folly called The Ruins, and statues of Queen Victoria and of Ceres, the goddess of plenty. Other areas were devoted to a bowling green, spaces for archery, and gymnastics.

Left: Near Pearson Park
The fountain at the junction of Park Avenue and Salisbury Street near Pearson Park.

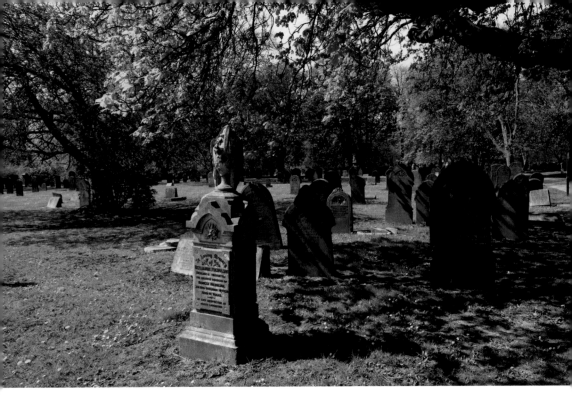

Above: Hull Cemeteries
The Western Cemetery to the east of Chanterlands Avenue. Hull General Cemetery was established in 1847 on Spring Bank. In 1862 the Hull Corporation established a cemetery next to this – Western Cemetery – and in 1890 extended it across Chanterlands Avenue. The General Cemetery contains a monument to a cholera outbreak in 1849; it closed in 1972 but the Western Cemetery is still in use.

Below: Queen's Gardens
Queen's Gardens, looking towards the Wilberforce Monument, in 1910. Queen's Gardens in the city centre is a range of gardens on what was Queen's Dock.

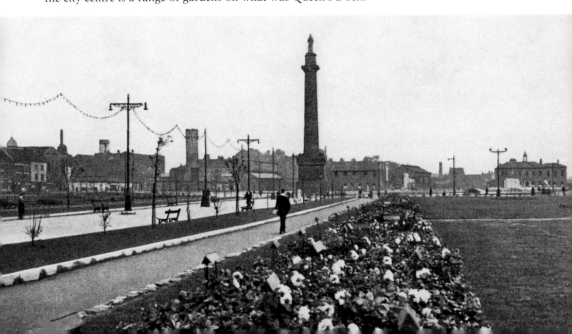

Public Buildings

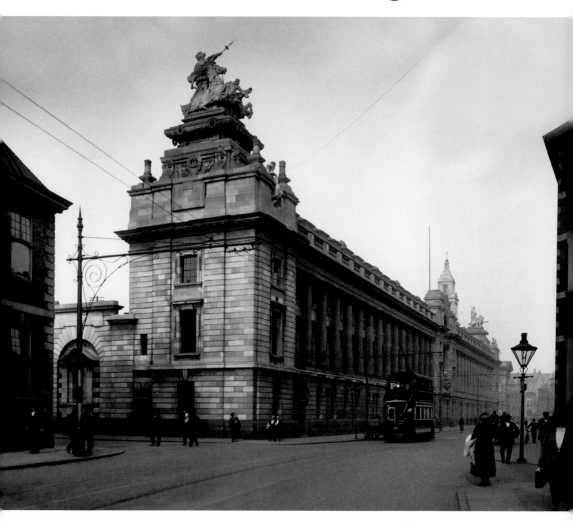

The Guildhall

The Guildhall, on Alfred Gelder Street, around 1910. The Guildhall emerged from the Town Hall and opened in 1866 at the north end of Lowgate. Soon after Hull was granted city status in 1897 a larger building was needed, so land to the west of the Town Hall was acquired for the present Guildhall, which opened with law courts, a council chamber and offices in 1907.

The Town Hall was demolished in 1912 and the east end of the Guildhall building was built between 1913 and 1916 in the Renaissance style. The Guildhall has treasures that include fine art, sculpture, furniture, the civic insignia, and silver. It boasts miles of oak and walnut panelling, marble floors and Hull's old courts and cells. *The Hull Tapestry* is also in the Guildhall. The cupola from the ornate 135-foot tower on the Town Hall was recycled to beautify the west end of Pearson Park.

The statuary on the Guildhall is quite stunning: the photo shows *Maritime Prowess* with the Greek goddess Aphrodite rising from the waves between two horses.

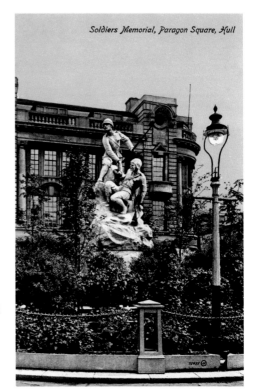

Soldiers Memorial, Paragon Square, Hull

Paragon Square
The Second Boer War (1899–1902) memorial in Paragon Square shows two sculptured soldiers in the uniform and accoutrements of the Second South African War, depicted in a battle vignette on top of a stone. Fifty-seven names of Hull's fallen are recorded.

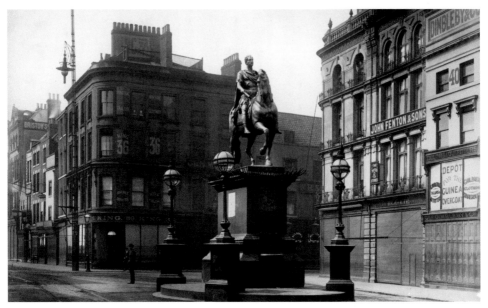

Statue of William III
In the centre is the equestrian statue of William III in the Market Place. The junction with Castle Street can be seen in the background. The statue was erected in 1734 in memory of William III and shows the king in Roman dress. The statue was sculpted by Peter Scheemakers around 1870–1910.

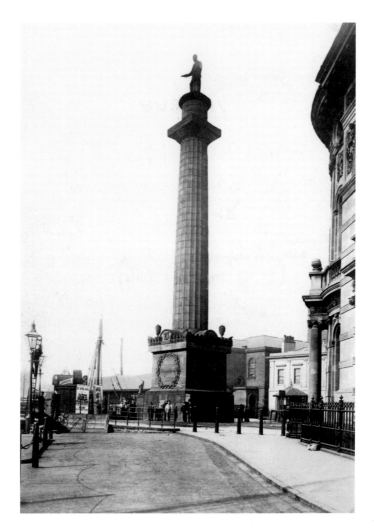

William Wilberforce Monument

The William Wilberforce Monument is 102 feet tall. It was built by Myers & Wilson of Carr Lane and stood by Princes Dock, at the end of Whitefriargate, for a century before being moved to the Hull College forecourt, at the end of Queen's Gardens, in 1935. Wilberforce was not just an abolitionist: the Wilberforce Memorial was the charity behind the Yorkshire School for the Blind in York. It was established in the King's Manor on the death of William Wilberforce in 1833 out of a desire to honour his memory and good works. Wilberforce represented Yorkshire as an MP for twenty-eight years. The school's mission was:

> To provide sound education together with instruction in manual training and technical work, for blind pupils, between the ages of five and twenty; to provide employment in suitable work-shops or homes for a limited number of blind men and women who've lost their sight after the age of sixteen, in some occupation carried on at the school; and to promote such other agencies for the benefit of the blind as may enable them to gain their livelihood, or spend a happy old age.

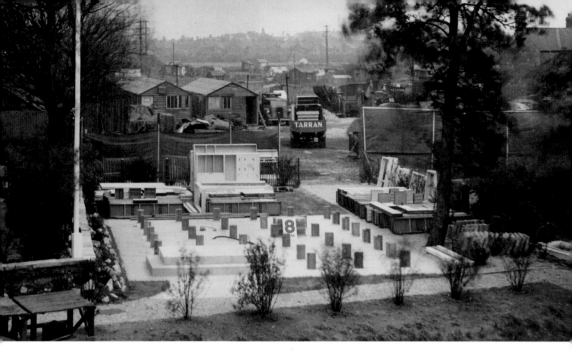

Tarran Industries Limited

Two, two-storey experimental houses, erected on 2 May 1944 in eight hours by Tarran Industries Ltd, Hull. Robert Greenwood Tarran (1892–1955) of Hull was a civil engineering contractor and managing director of Tarran Industries Ltd. He was a member of Hull City Council and served as sheriff of Hull and as its chief air-raid warden during the Second World War, during which he organised the evacuation of civilians from Hull. Tarran built up his company from scratch, and eventually employed 10,000 people. Under contract with the Ministry of Defence, the company built airfields and coastal defences, in addition to its civil contracts. The company designed and made prefabricated houses during the Second World War, almost 20,000 of which were erected during the latter years of the war and immediately after it under the Housing (Temporary Accommodation) Act 1944.

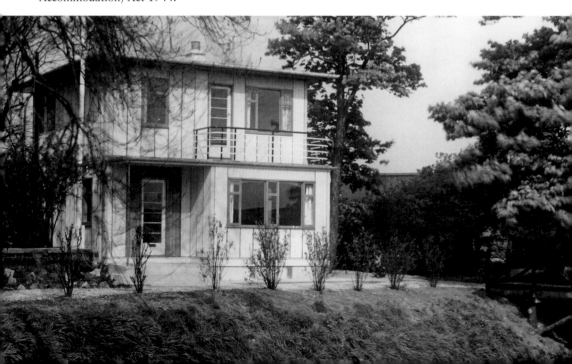

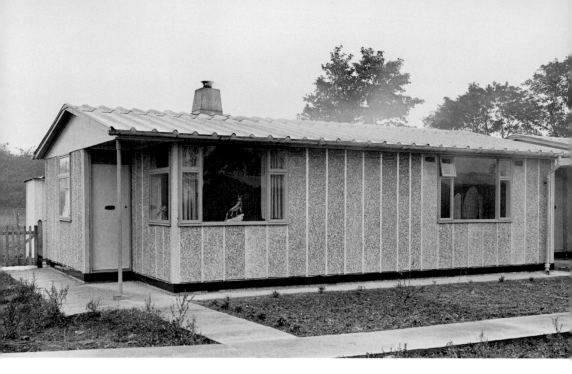

Tarran House

Above: A prefabricated Tarran House at No. 5 Hopewell Road, Hull, on 27 August 1945. The Tarran was designed as a wooden-framed bungalow clad with precast concrete panels. There were 19,014 Tarrans erected under the Temporary Housing Act. One- and two-storey variants were built afterwards.

Below: The living room at No. 5 Hopewell Road.

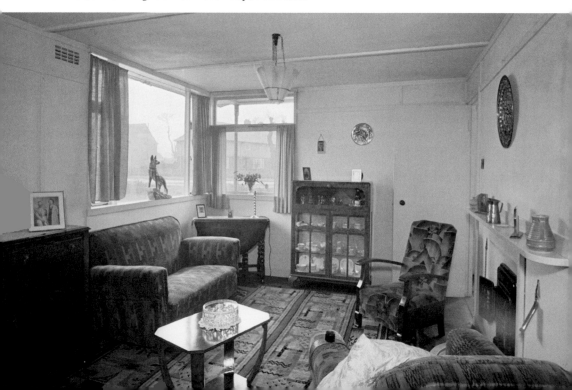

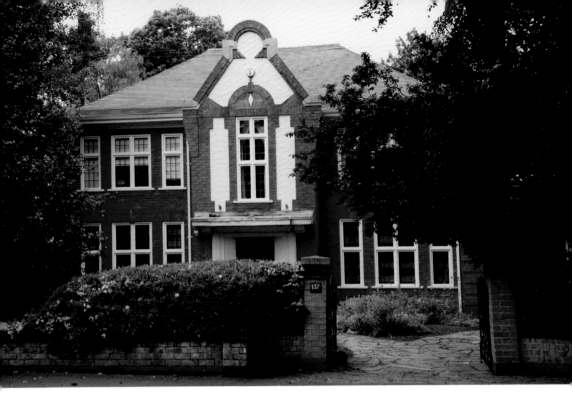

Newland Park

Above: Number 137 Newland Park. Modern Newland includes the former site of the Kingston upon Hull Municipal Training College (est. 1913). The University of Humberside was added here later, now part of the University of Hull, as well as the Newland Park estate where a number of the houses are in an Arts and Crafts style.

Below: Also in the area is the former Endsleigh Convent (built in 1876), the former Sailors' Orphan Homes (opened in the 1890s, and seen to the right), and the modern Humberside Police headquarters (2012).

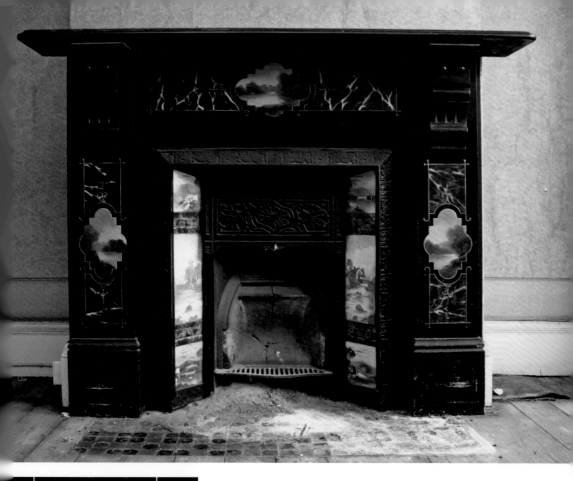

Bacheler Street
The fireplace in a ground-floor room in the terraced house
at No. 42 Bacheler Street, along with a detail of one of the
glazed tiles.

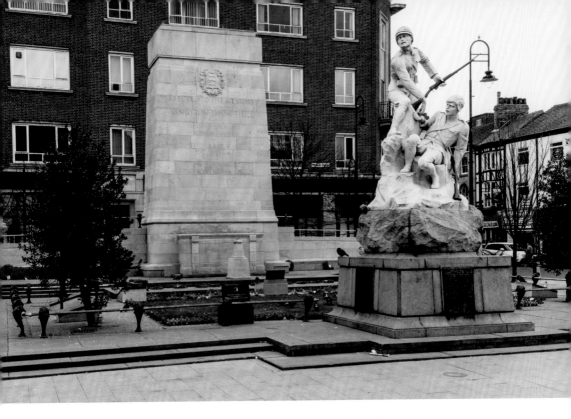

First World War Memorial, Ferensway, and the Boer War Memorial
'The Hull Cenotaph is a simple, design, devoid of any representations of heroism and victory, or any religious symbolism. It provides a blank canvas for the viewer to project their own feelings of war. Hull's Cenotaph remains a successful design.'
(http://www.ww1hull.org.uk/index.php/hull-in-ww1/remembrance.)

The Kingston upon Hull war memorial was unveiled at the French village of Oppy in October 1927 to remember the men of Hull and all local units who gave their lives in the First World War; many of the casualties of the 31st Division who died at Oppy were from the Hull area. The memorial stands on ground donated by the Vicomte and Vicomtesse du Bouexic de la Driennays in memory of their twenty-two-year-old son Pierre, an NCO of the French 504th Tank Regiment, who was killed in action at Guyencourt on 8 August 1918.

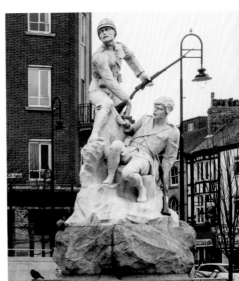

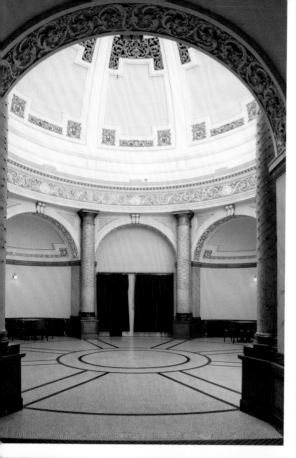

City Hall

Inside the City Hall, looking into the domed Mortimer Suite with the staircase hall below. The Baroque Revival-style Hull City Hall was part of Hull Corporation's 'Junction Street' scheme in 1900, designed to form a central square in the city to be known as Queen Victoria Square. The proposed City Hall was to include a main hall and three reception halls on the first floor, with the main entrance looking out onto the square.

This main hall was to have side and rear galleries, and an orchestra that could hold up to 3,000 people. In 1905 an art gallery was proposed for the first floor in one of the smaller halls. Accordingly, the Victoria Art Gallery opened in 1910 and survived until 1927 when a new building was opened, later known as Ferens Art Gallery.

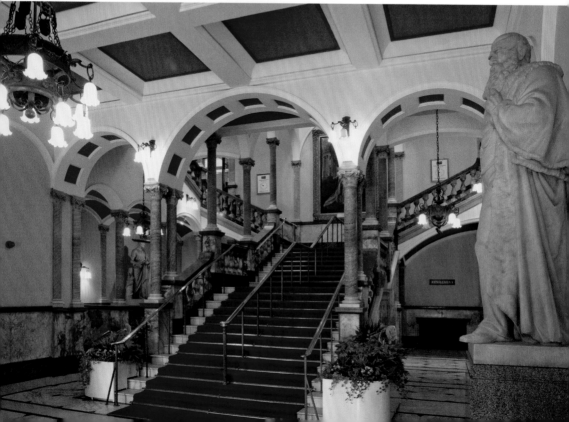

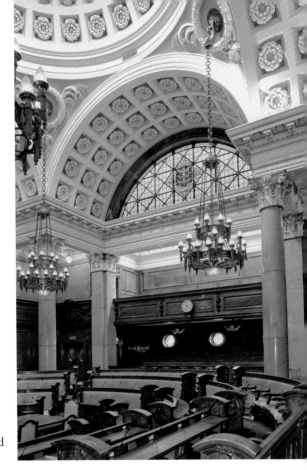

Guildhall Council Chamber
This interior view of the Council Chamber
is looking towards an arched recess
ornamented with decorative plasterwork and
a tympanum painting.

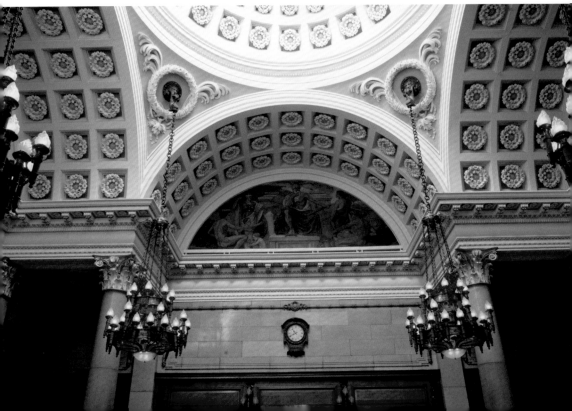

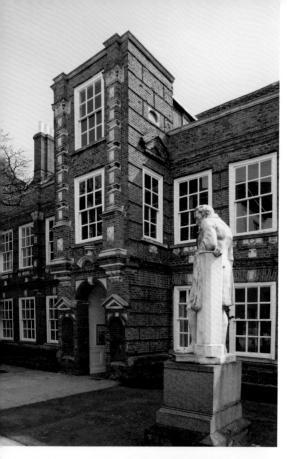

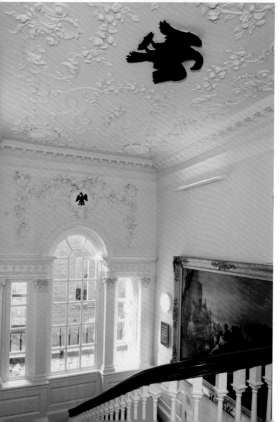

Wilberforce House and the Statue of
William Wilberforce
Below left is an interior view of the museum
looking down a staircase. Wilberforce House
is Hull's oldest surviving museum. It opened
in 1906 and is dedicated to Wilberforce and
his campaign to abolish the slave trade. The
building was originally built in the 1660s for
one of the Listers, a family of Hull merchants.
Sir John Lister entertained Charles I here on
his first visit to Hull. In 1709 the house passed
to John Thornton, a prominent exporter of
cloth and lead at that time. One of Thornton's
apprentices was William Wilberforce, who had
moved to Hull from Beverley to work. This
Wilberforce was the grandfather of the famed
abolitionist, who married his master's daughter
in 1711. The house passed to Wilberforce in
1732 while the family made their fortune in the
Baltic trade.

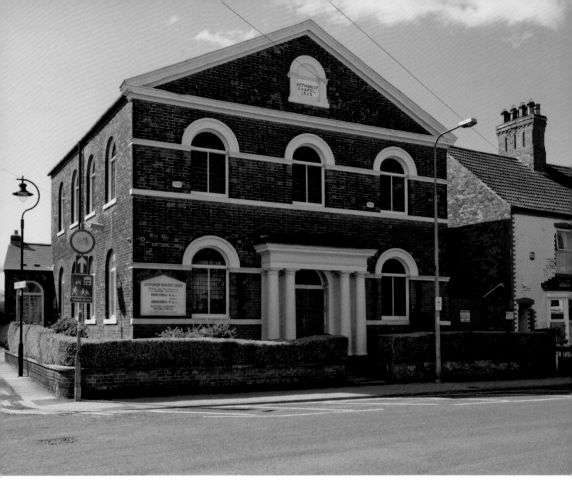

The Methodist Chapel, Church Street, Sutton-on-Hull

RAF Sutton-on-Hull was originally RAF 17 Balloon Centre when it opened on 28 June 1939 to provide the balloon barrage to defend Hull and the Humber area. By September 1942 over 2,000 Royal Air Force and Women's Auxiliary Air Force personnel served here. It became the home of the RAF School of Fire Fighting and Rescue from 1943–59.

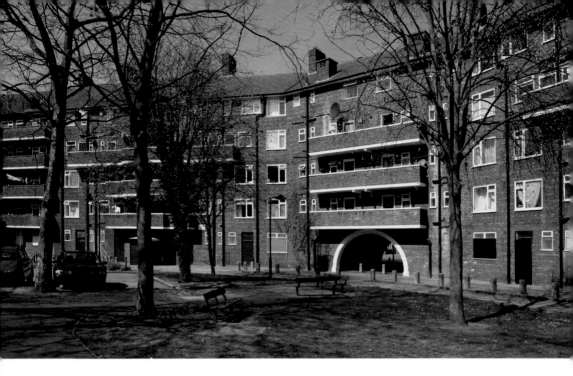

Thornton Estate

Above: The Thornton estate, to the west of Hull city centre, was built between the late 1940s and the 1970s by Hull City Council. It is a mixture of high-rise flats, low-rise flats, houses, and the (now demolished) 'Misery Maisonettes'. The earliest part was built soon after the Second World War, starting with the 'Australia Houses'. This was a circular five-storey housing block off Porter and Adelaide streets, with a communal garden in the middle. These flats consisted of deck access flats and some art deco tenements.

Below: The Auckland and Melbourne houses.

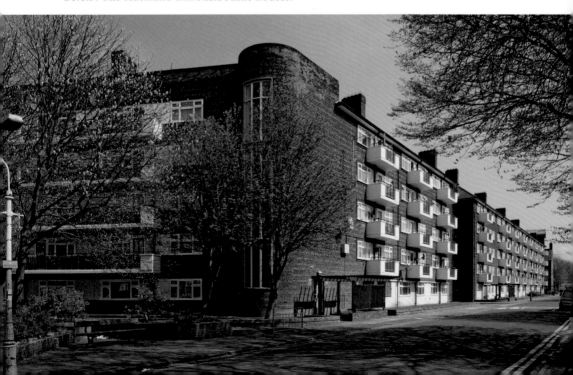

Prince Street
Prince Street exemplifies the transformation in Hull of much of its housing. In the early 1970s it was rundown and almost derelict, but now it's an elegant row of terraced homes.

Springhead Pumping Station, Willerby
This started life as a pumping station in 1863 and then became a waterworks museum. In 2017 a complete refurbishment was completed. It is a listed building and has been described thus: 'This building and engine are representative of C19 municipal water works, and illustrate how … an architecture founded in objective functionalism … could be used to create a polite and elegant building whose purpose was nevertheless unmistakeable.' ('Yorkshire Water Museum: Springhead Pumping Station – A Brief Description'; Bristol Polytechnic T&CP Working Paper No. 28: Douet J., *Temples of Steam*).

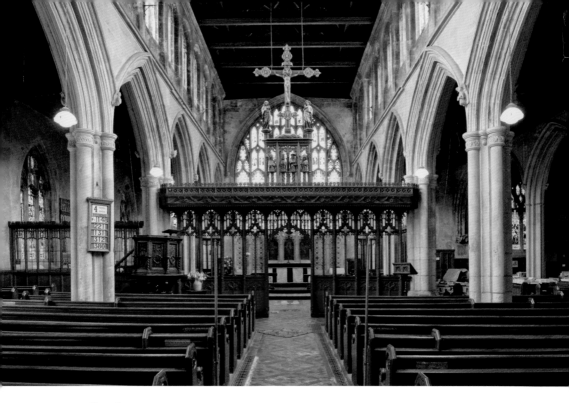

St Mary's Church
St Mary's Church, Lowgate, looking east along the nave. Below are carved angels on the corner of an archway. Dating from 1333, St Mary's is one of Hull's oldest churches.

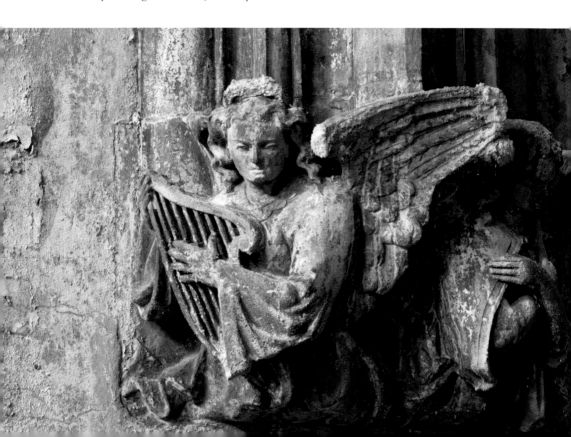

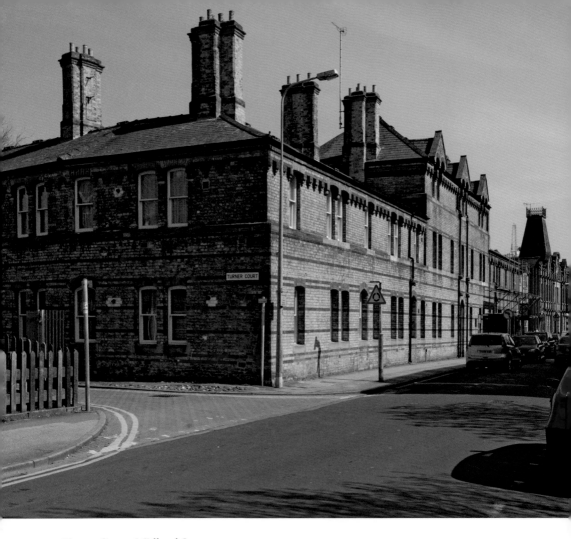

Turner Court, Midland Street

The Society for Improving the Condition of the Labouring Classes, chaired by Lord Shaftesbury, worked to improve the housing conditions for the poor. In Hull it inspired two ladies to enable the building of 'model dwellings' in the city. Miss Broadley gave land on the corner of Midland Street and St Luke's Street, near St Luke's Church. Miss Turner gifted the money for the building work. According to the website:

There were 32 flats; 5 one-bedroomed, 19 two-bed roomed and 8 three-bedroomed. Each was to have a scullery and "other necessary conveniences". An indoor lavatory was then a considerable luxury. The building was to be two storeys high, except for the centre portion, which had three storeys. It was to be built of white brick, with bands and cornices of red brick. The cost was to be £3,435.

(http://www.hullwebs.co.uk/content/k-victorian/city/turner-court/turner_court.htm.)

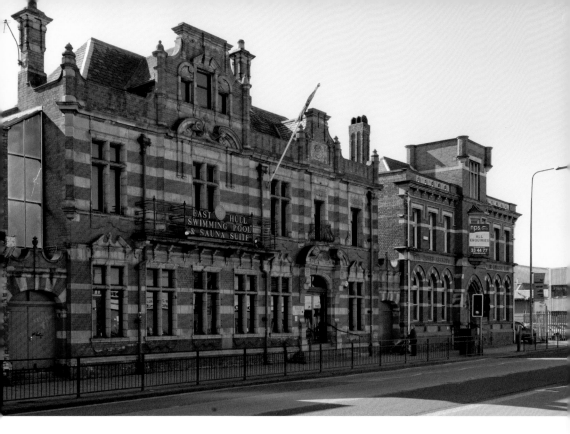

James Reckitt Library

James Reckitt Library in Holderness Road opened in 1889 next to the East Hull Baths. It was Hull's first free library and was established by James Reckitt with more than 8,000 books. The library was donated to the borough of Hull in 1892 when the city adopted the Public Libraries Act. The library closed in 2006.

Reckitt's other acts of philanthropy include the Garden Village (1908). This is a 600-home model village built for his workers in Hull, which was run as a non-profit organisation during his lifetime. He also financed a hospital in Withernsea, contributed to the Sailors' Orphan Homes, and actively promoted the establishment of the Hull Royal Infirmary. He set up the Sir James Reckitt Charity in 1921, which supports charitable and Quaker organisations.

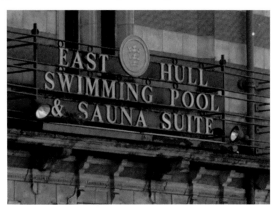

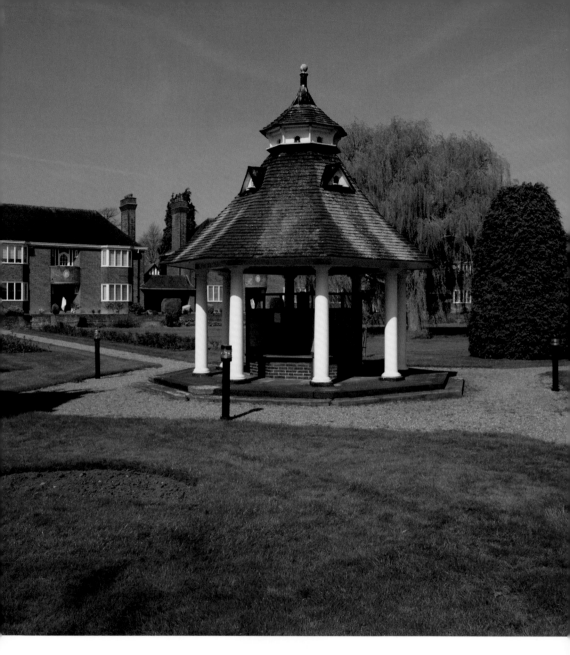

Lee's Rest Houses

Lee's Rest Houses, Anlaby Road, East Ella, were built in 1914–15 when Dr Charles Alfred Lee (1825–1912) left £200,000 to build a complex of sixteen detached blocks, each containing eight flats. The buildings are neo-Georgian and arranged around a quadrangle of grass and gardens, with a central pavilion containing a reading room and clock tower with a cupola. The homes were designed to be housing for the elderly. Stipends were 10s for a single person and 12s 6d for a married couple. To qualify, applicants must have resided or carried out business in Hull for five years preceding their application. Preference was given to those who had seen better circumstances and been in good positions but who, through misfortune or sickness, had been reduced to poverty.

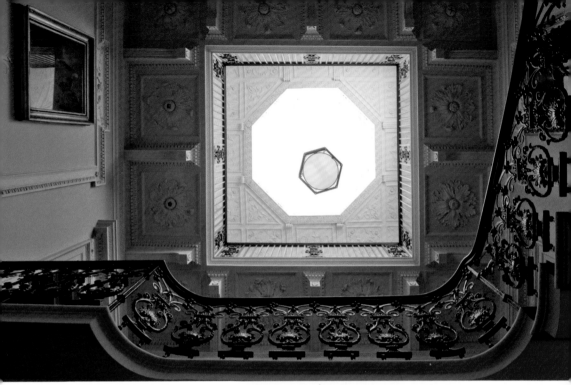

Maister House

Maister House at No. 160 High Street, looking up towards the octagonal lantern in the ceiling of the house's staircase hall.

Rebuilt in the Palladian style after a fire in 1743, this merchant's house evokes Hull's commercial heyday. Inside, jewels cover the wrought-iron balustrade to the stairs and gallery, and in the wall above the stairs (seen on the right here) is a niche containing a statue of Ceres, the goddess of plenty; on the opposite wall is a plaque celebrating the philosopher John Locke.

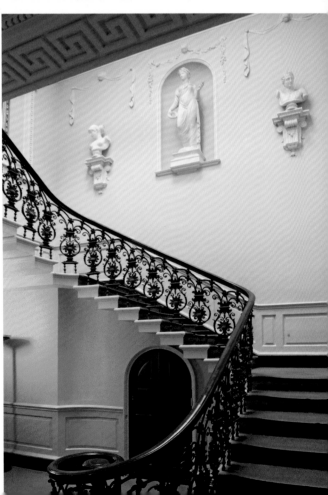

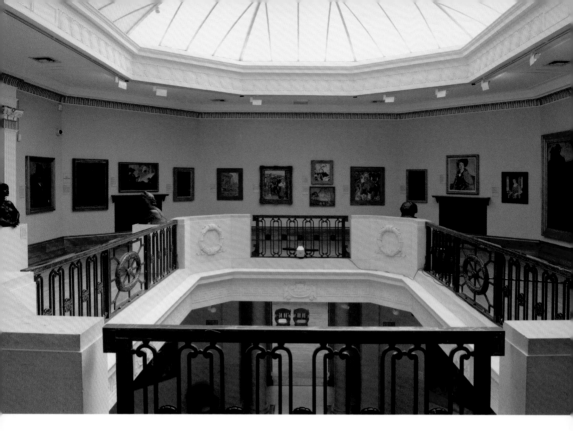

Ferens Art Gallery

Ferens Art Gallery, Queen Victoria Square, looking across the upper level. The site and construction of this major provincial gallery was donated by Thomas Ferens. It opened in 1927 and was restored and extended in 1990. It reopened in January 2017, after a major £4.5-million refurbishment, in time for it to host the 2017 Turner Prize as part of the UK City of Culture programme.

Gallery highlights include Lorenzetti's *Christ Between Saint Paul and Saint Peter* (1320), which cost £1.6 million, Frans Hals' *Portrait of a Young Woman* (1660s), Francesco Guardi's *Sophronia Asking the Saracen King Aladine to Release the Christian Prisoners* (c. 1745), Antonio Canaletto's *The Grand Canal, Venice* (c. 1724), Frederick Leighton's *Farewell* (1893) and *Electra at the Tomb of Agamemnon* (c. 1869), John Atkinson Grimshaw's, *Princes Dock, Hull*, Walter Sickert's *Hotel Royal, Dieppe* (1899), Herbert Draper's *Ulysses and the Sirens* (1909), and works by Stanley Spencer, David Hockney, Helen Chadwick and Gillian Wearing.

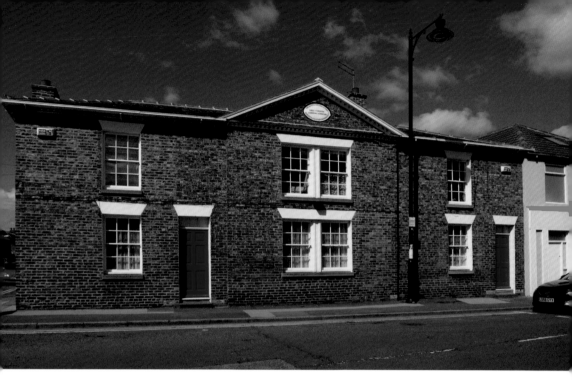

Chamberlain Almshouses

The Chamberlain Almshouses on College Street, Sutton-on-Hull, which date from 1800. The image below shows a detail of the plaque on the central pediment, with an inscription noting its construction date of 1800 and the names of its dedicating trustees.

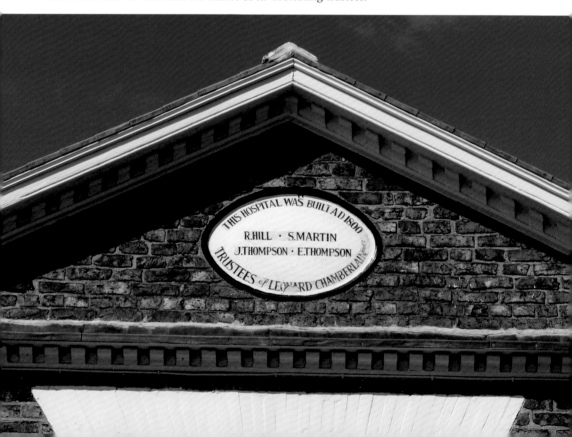

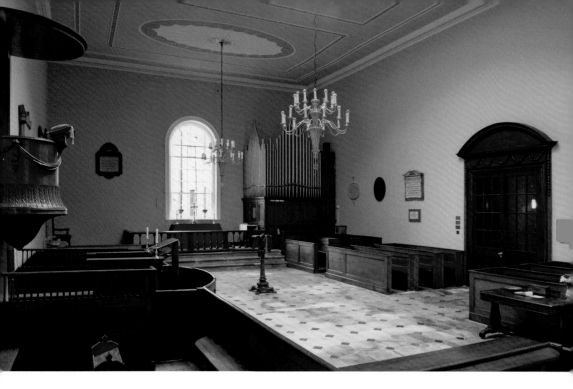

Charterhouse, Charterhouse Lane

Hull Charterhouse (known simply as 'the Charterhouse') was a Carthusian monastery and almshouse that survived the Dissolution of the Monasteries; however, the priory was destroyed in 1538. The hospital was destroyed before the first siege of Hull during the English Civil War to prevent it being used by besieging forces. A replacement was built in 1645, which was replaced again in 1780. The buildings function as an almshouse with an attached chapel. In the 1860s the hospital cared for seventy pensioners, each with an allowance of 6s per week.

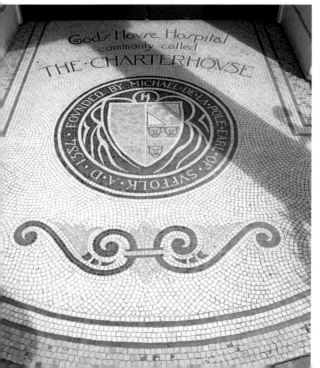

This image shows the mosaic flooring in the Charterhouse chapel, including an inscription and the arms of Michael de la Pole. The inscription reads 'God's Hovse [sic] Hospital commonly called The Charterhouse Founded by Michael De La Pole Earl of Suffolk AD 1384.'

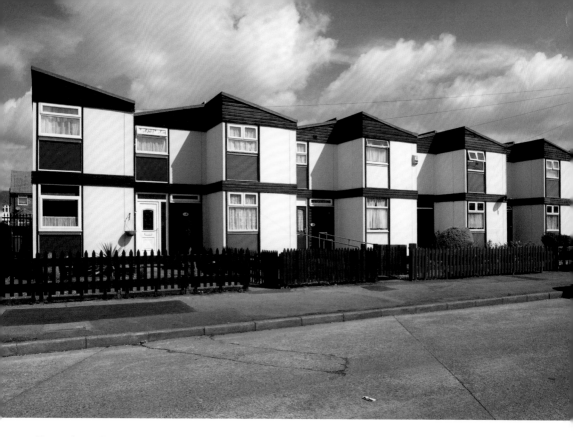

Rustenburg Street
Above are Nos 145–153 Rustenburg Street.

Below is a general view looking north-west along a terrace on the north side of the street from Nos 165–173. These pictures show the diversity of modern housing in Hull.

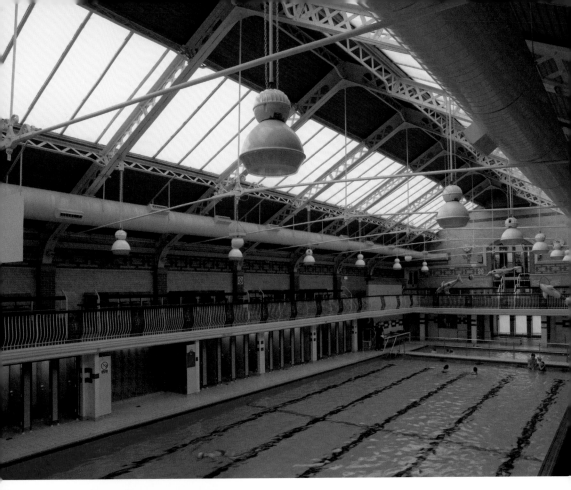

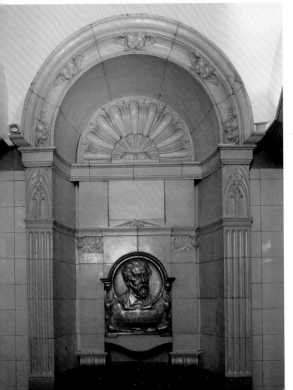

Beverley Road Baths, 2006
On the left is an alcove with decorative moulding, and there is also a brass plaque featuring the head of John Shaw, chairman of the Baths Committee. The baths opened in May 1905 and the Victorian Society describes them as: 'an impressive monument to turn-of-the-century civic pride. A central square tower topped by an octagonal cupola marks out the entrance, and another smaller cupola with a copper dome turns the corner into Epworth Street. To the right, the gabled end of the pool hall, decorated with a Palladian window. This is a baths complex which wants to be noticed!'

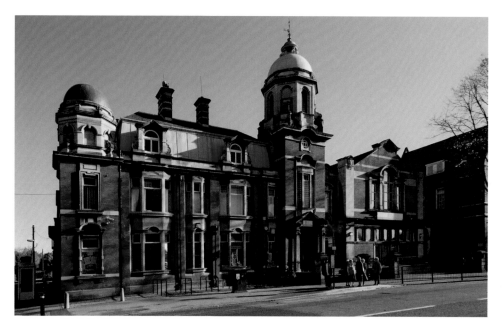

Beverley Road Baths
Below is a detail of a floor mosaic in the foyer. There were separate baths for men, women and boys.

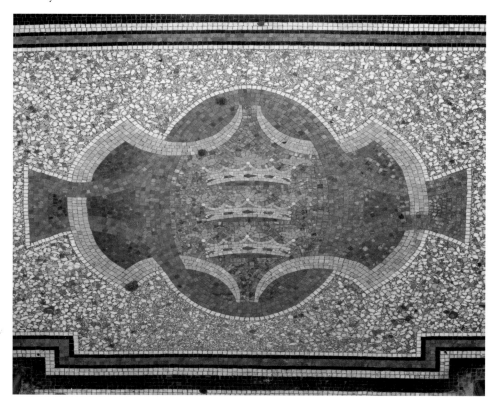

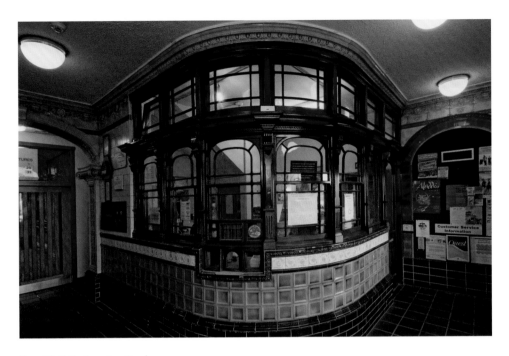

East Hull Swimming Pool

East Hull Swimming Pool on Holderness Road, showing the counter in the entrance hall in 2006, along with an interior view. Baths opened in 1885 on Madeley Street, then in 1898 the East Hull Baths opened on Holderness Road. The Beverley Road Baths came next in 1905, and in 1908 the Newington Baths were opened in Albert Avenue on the site of the former Newington Water Company works. All four included slipper baths, and all but those in Albert Avenue were covered baths. Electromedical and vapour baths were added at Beverley Road in 1927, and covered baths were built at Albert Avenue in 1933.

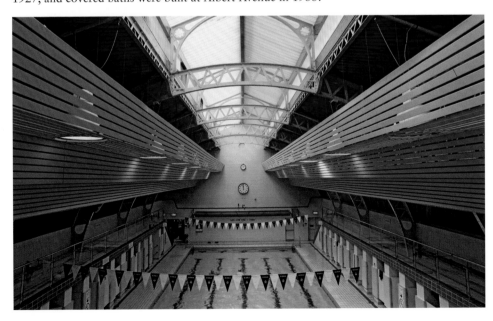

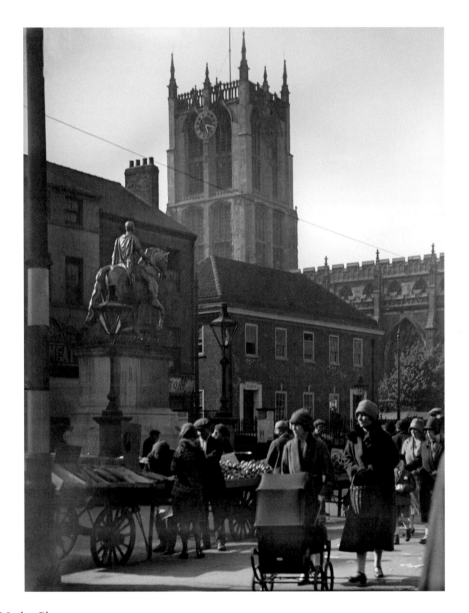

Market Place
A typical Hull scene: a bustling Market Place with the mounted statue of William III and Holy
Trinity Church (now Holy Trinity Minster) in the background, The image dates from around
1920. In 1293 two weekly markets were established in Hull on Tuesdays and Fridays. At first
the market was held on either side of Marketgate, parts of which were later named as Butchery,
Market Place, and Lowgate. In 1469 it was all restricted to south of Whitefriargate to Silver
Street and Scale Lane. The years 1762 and 1771 saw the street enlarged. In 1804 Butchery was
widened and renamed Queen Street, then extended south to Ferry Boat Dock. Humber Street,
from Queen Street to Humber Dock, became an extension of the market. Two market halls
were built to reduce crowding; the first, on the site of the butchers' shambles at the junction of
Blackfriargate and Queen Street, opened in 1887, boasting 109 stalls and twenty shops.

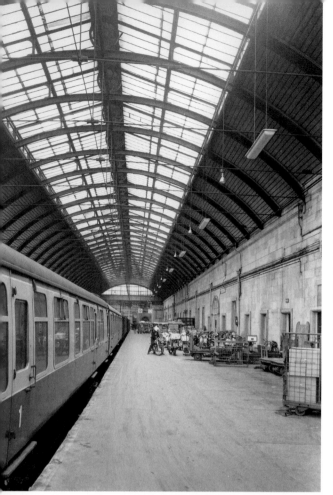

Paragon Station

Platform 5 at Paragon Station in 1979 – below we see the wooden cafeteria building inside the station. Paragon Station and the Station Hotel next door were both designed by the railway architect G. T. Andrews. The station opened in 1848 to serve as the new Hull terminus for the growing traffic of the York & North Midland Railway (Y&NMR), leased to the Hull & Selby Railway (H&S). The station was also the terminus for the Hull to Scarborough line, and from the 1860s was the terminus of the Hull & Holderness, and Hull & Hornsea railways. The station and hotel were both built in the Italian Renaissance style, with both Doric and Ionic elements. The façades were inspired by the interior courtyard of the Palazzo Farnese in Rome.

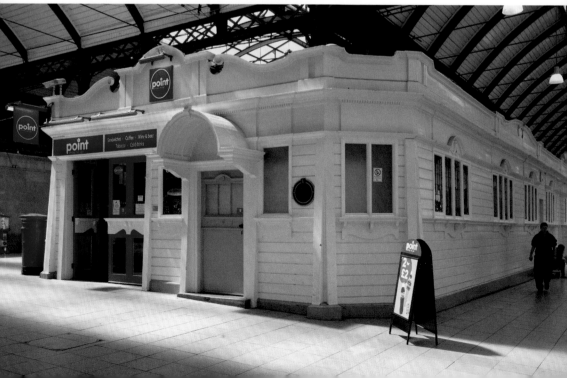

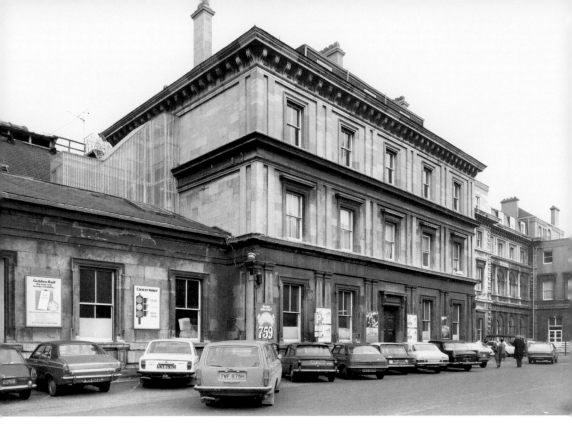

Paragon Station, Ferensway, 1975

Queen Victoria stayed in the Station Hotel in 1854. The station's name, Paragon, comes from the nearby Paragon Street, which was itself built around 1802. However, the name itself is earlier still: the Paragon Hotel public house (now the 'Hull Cheese') gave its name to the street, and dates back to 1700. The station was opened as 'Hull Paragon Street' on 8 May 1848.

In the early 1900s the North Eastern Railway (NER) expanded the train shed and station, erecting the five-arched platform roof we see today. On 5 March 1916, during the First World War, a Zeppelin raid killed seventeen people when a bomb blast blew out the glass in the station roof. A bus station was built next door in the mid-1930s. The rail station took direct hits on the night of 7 May 1941 during the Blitz; the signal box was badly damaged when a parachute mine exploded nearby and the small railway museum was destroyed by fire. Paragon Interchange opened in September 2007, integrating the city's railway and bus termini.

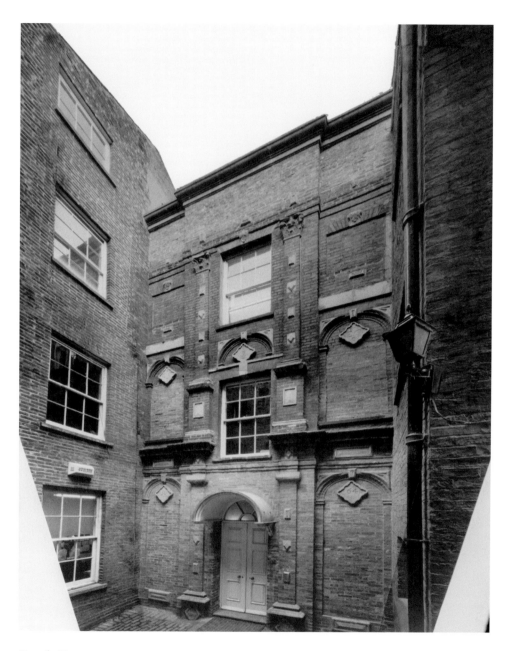

Crowle House
Crowle House at No. 41 High Street in 1993, which was built for Alderman George Crowle around 1640 and was the home of the prominent Crowle family for many years. George Crowle was one of Hull's wealthiest merchants, making trade deals in the Low Countries, Scandinavia and the Baltic. He was sheriff of Hull in 1657 and mayor in 1661, then again 1679. He also founded an almshouse in Sewer Lane in 1661. William Catlyn, a local bricklayer and architect who designed Wilberforce House, created the designs for Crowle House.

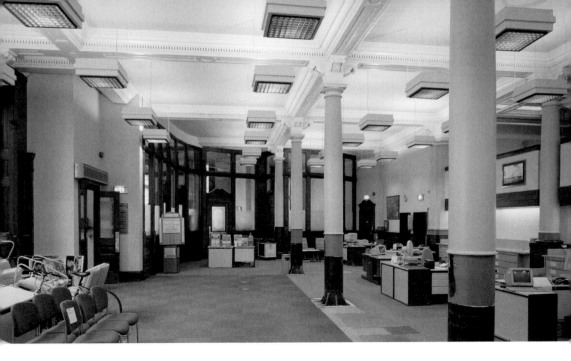

A Commercial City

Here are images that illustrate Hull's pre-eminence as a commercial city. The first is of Barclays Bank at Nos 1–3 Trinity House Lane, showing the banking hall in 1997. (© Crown copyright. Historic England Archive) The second shows the interior of the Prudential Buildings in 1904, looking from the manager's room towards the entrance on King Edward Street. The Prudential Buildings were destroyed on 7 May 1941 when high explosives hit the building killing fifteen people sheltering in the basement.

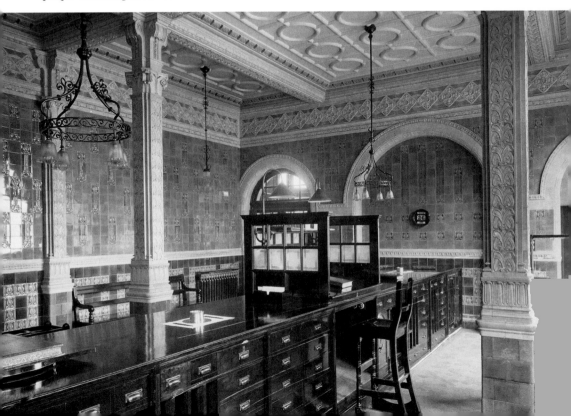

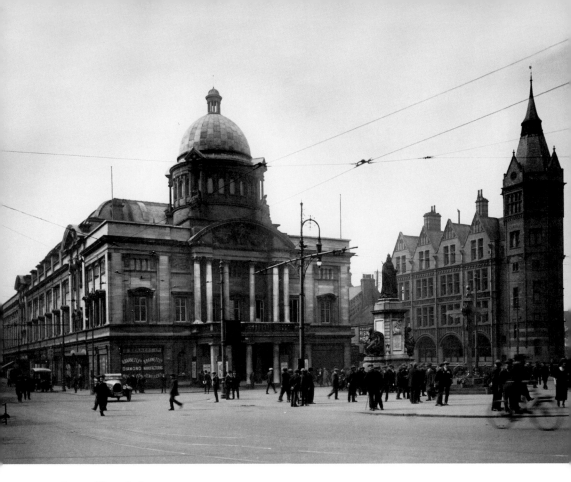

Queen Victoria Square

The City Hall and the 1903 statue of Queen Victoria in Queen Victoria Square around 1915. The larger-than-life 35-foot statue, like the 1923 subterranean municipal toilets beneath, is listed. The statue almost avoided being placed above these lavatories, and would have done so if the Queen's Memorial Committee had got its way. The minutes of the committee from 22 February 1923 tell us: 'resolution passed that the statue of Queen Victoria taken down in the City Square be not erected over the new public lavatory.' However, later minutes reveal that the statue had been re-erected in the square – over the toilets – by January 1924.

HMP Hull

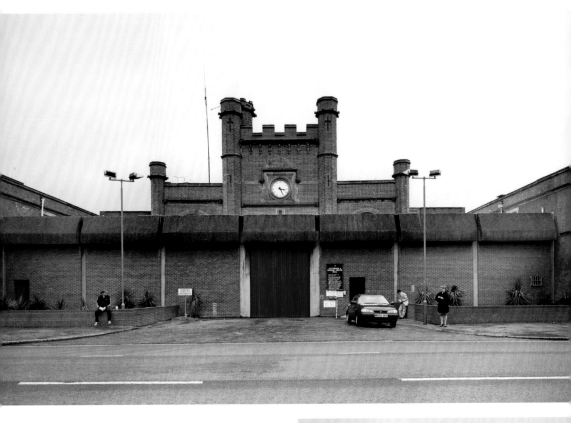

The Gatehouse

The gatehouse at HMP Hull, Hedon Road, in 1996. The prison opened in 1870 to house men and women. In the Second World War it was a civil defence depot and military prison. In 1955 it was a borstal. The only woman to be hanged at Hull was Ethel Major of Kirby-on-Bain, Lincolnshire. She was convicted of poisoning her abusive and often drunk husband, forty-four-year-old lorry driver Arthur, using strichnine in his corned beef. Arthur Major made the mistake of demanding to know the identity of the father of Ethel's daughter, Auriel, who was passed off as Ethel's sister.

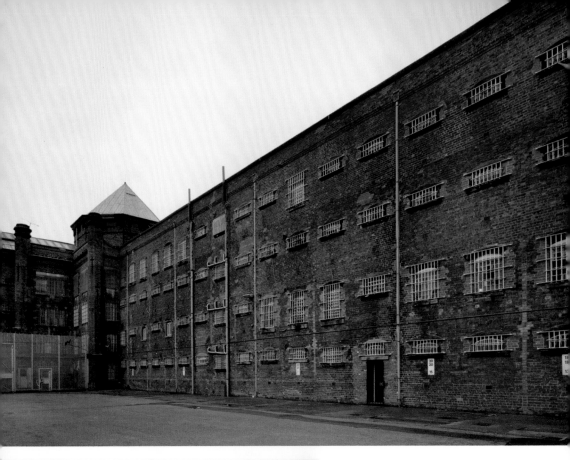

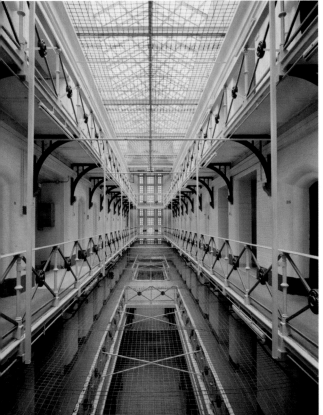

C-Wing

Some of the executed at Hull:

Arthur Richardson (thirty) on 25 March 1902. Murdered his aunt.

William James Bolton (forty-four) on 23 December 1902. Stabbed his former girlfriend to death.

Charles William Aston (nineteen) on 22 December 1903. Shot his former partner.

Thomas Siddle (twenty-nine) on 4 August 1908. Cut his twenty-two-year-old wife's throat.

John Freeman (forty-six) on 4 December 1909. Murdered his sister.

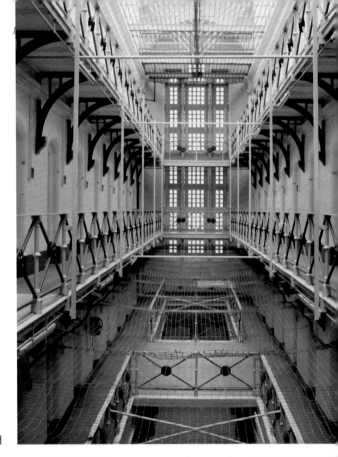

Inside the Prison

Some more of the executed at Hull:

William George Smith (twenty-six) on 9 December 1904. Killed a woman he was 'on friendly terms with' in front of her three children.

Hubert Ernest Dalton (thirty-nine) on 10 June 1925. Murdered a colleague.

George Emanuel Michael (forty-nine) on 14 April 1932. Stabbed his partner several times in the head and throat, before attempting to kill himself.

Roy Gregory (twenty-eight) on 3 January 1933. Murdered his two-year-old stepdaughter. He struck her over the head with a hammer, before hiding her body in the cellar behind a wall. Her body lay undiscovered for five months.

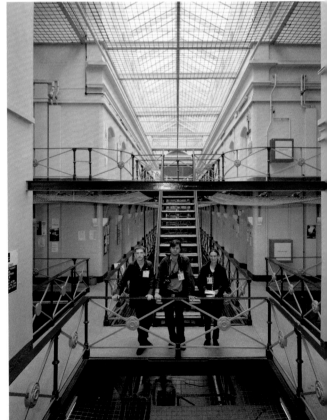

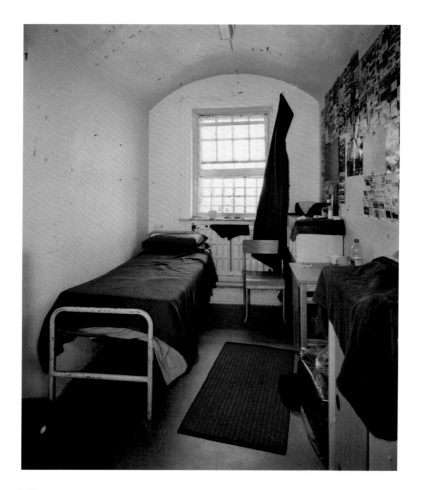

Inside a Cell

Twenty-one-year-old John Aaron Walker was convicted of the murder of his father in 1901, also called John Aaron Walker, and was sentenced to death but won a reprieve due to his age. He had stabbed his father in the chest, killing him almost instantly, in Raywell Street, Hull. Son and father had argued over alleged 'misconduct' between John Walker and his stepmother, Charlotte Walker. When the father had come downstairs threatening to destroy the house, John Walker Jnr threw him onto a chair and stabbed him in the heart with a knife, saying that he always knew 'I would do for you'. John Walker Jnr's stepmother said that he had been living with them for four years or so, although he had spent most of that time in prison.

He was charged at Norfolk Street police station with the murder of his father, after which he was committed to trial at York Assizes. Here he was found guilty of murder with a strong recommendation for mercy on account of his relative youth and the provocation. He received a sentence of life imprisonment and the newly built gallows at Hull had to wait for their first victim.

The gallows at Hull were specially built for Walker but his reprieve meant that he missed out on the dubious privilege of being the first to hang there; Hull convicts had previously hanged at York or Armley.

Inside the Prison
Keep the homefires burning: an attempt to make the cell more homely. Also shown is the prison chapel.

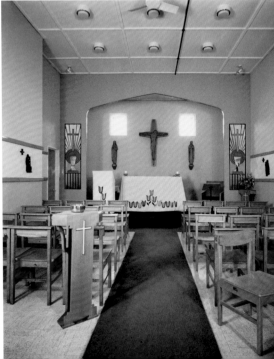

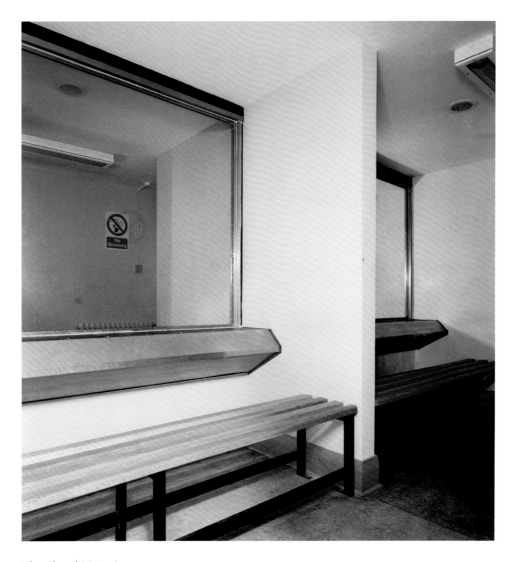

The Closed Visits Area

In 1901 Arthur Richardson was convicted of the murder of his aunt, Sarah Hebden, aged sixty-two, and sentenced to death. He had battered her to death at No. 97 Hodgson Street, Hull, on Thursday 28 November 1901.

Sarah Hebden used to collect premium money for the Royal Liver Friendly Society for which she received a commission. She also had a tea caddy in which she generally kept between £5 and £10. Arthur Richardson had previously stolen from another aunt and had only been released from prison eight days before he murdered Sarah Hebden.

On 28 November 1901, Sarah Hebden failed to make a visit she had arranged to Elloughton. Neighbours found a window open at the back of the house; they went in through the window and found Sarah Hebden dead at the foot of the stairs. Later, Arthur Richardson's landlord said that Richardson had complained to him that he had no money but then he saw him later with money in his pockets. When arrested, the police found a gold watch on him and a brooch that belonged to Sarah Hebden, along with bloodstains on his clothes and boots. Richardson was found guilty of murder and hanged at Hull prison.

The Docks

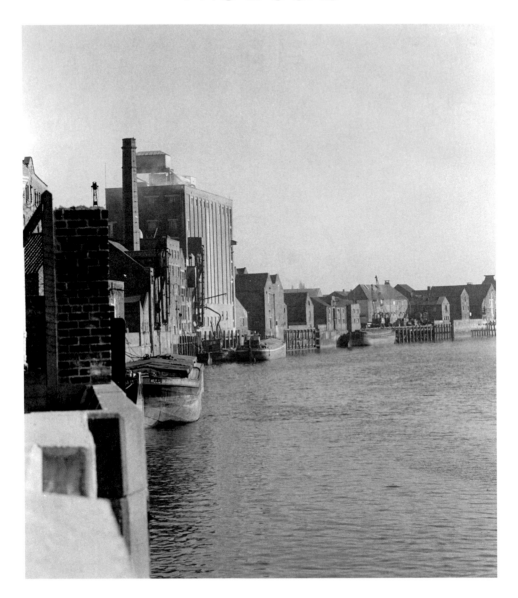

Riverside Warehouses
Riverside warehouses with barges moored on the River Hull by Morley Street, off Stoneferry Road. The Haven (Old Harbour) is the lower part of the River Hull as it flows toward the Humber. From the earliest days this was the main assembly point for vessels loading and unloading their cargoes, but, as the numbers of boats increased in volume and size, the busy waterway became overcrowded. To cater for this, the first enclosed dock was completed in 1778; its excavation necessitated the removal of the northern section of the city's walls. This was followed by the Humber Dock in 1809 and the Junction Dock (Prince's Dock) in 1829.)

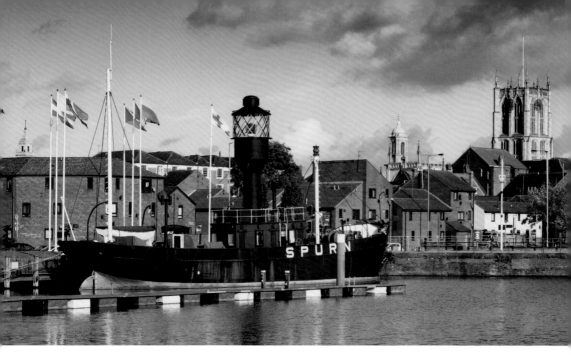

Humber Dock

Looking north-east across the dock towards the *Spurn Lightship*, with Holy Trinity Church beyond. The Town Docks were extended in 1846 with the construction of the Railway Dock, which was monopolised by the Wilson Line – then Hull's biggest steamship company.

The Victoria Dock was opened in 1850 with timber as its main commodity, imported largely from the Baltic. The Albert Dock opened in 1869 for general cargo, also becoming home to the North Sea fishing fleet, while in 1883 St Andrew's Dock, originally intended for the coal trade, absorbed the increase in fishing with an extension added in 1897. Alexandra Dock opened in 1885 and a riverside quay was established in 1907, south of the Albert Dock, so that ships with perishable cargoes could be unloaded promptly.

The *Spurn Lightship* can be seen below, moored in the marina beside Castle Street and Princess Quay shopping centre.

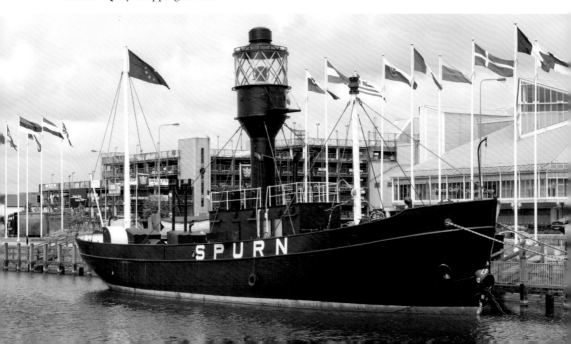

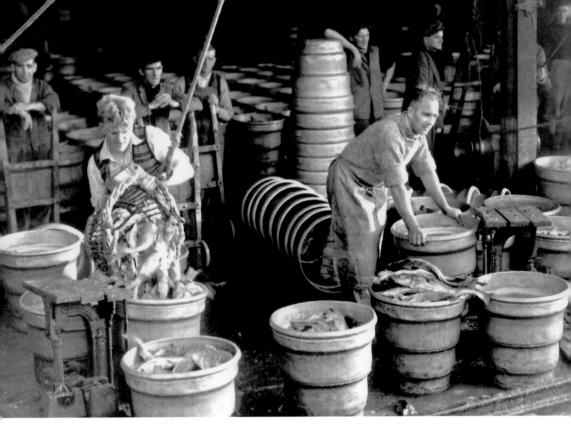

St Andrew's Dock

By the 1880s fish and fishing had become so important to Hull's economy that a new dock earmarked for coal was repurposed as a fish dock – St Andrew's Dock, named after the patron saint of fishermen. It extended more than 10 acres with room for stores, factories and offices for the fish trade, as well as for mast and block makers, iron founders, blacksmiths and shipwrights. In 1895 work started on extending the dock; the new facility opened in 1897. St Andrew's Dock was naturally the focus for smokehouses for making kippers, and the 'cod farm' was the place where prodigious amounts of cod were split, salted, dried and exported.

The Arctic Corsair Whaler
This is now a floating
museum.

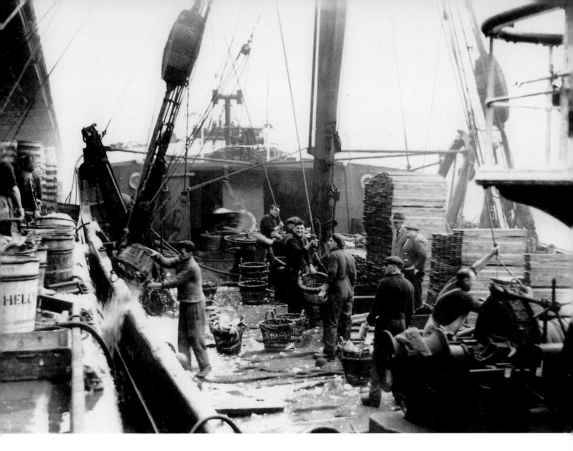

Hull Fish Quay
Hull Fish Quay was implicated in an international incident involving Hull trawlers and the Russian Baltic fleet on 21 October 1904 – this became known as the Dogger Bank Incident, or the Russian Outrage. Mistaking Hull trawlers for enemy Japanese boats, Russian warships opened fire on the fishermen, killing a Hull skipper and a third hand, and seriously wounding seven others. The trawler *Crane* was sunk and the hospital mission ship *Joseph and Sarah Miles* went to assist. Returning to St Andrew's Dock, the vessels showed clear evidence of the damage caused – protests to the Russian government went unheeded. A relief fund was set up and on 30 August 1906 a fine memorial was unveiled outside St Barnabas's Church in Hessle Road.

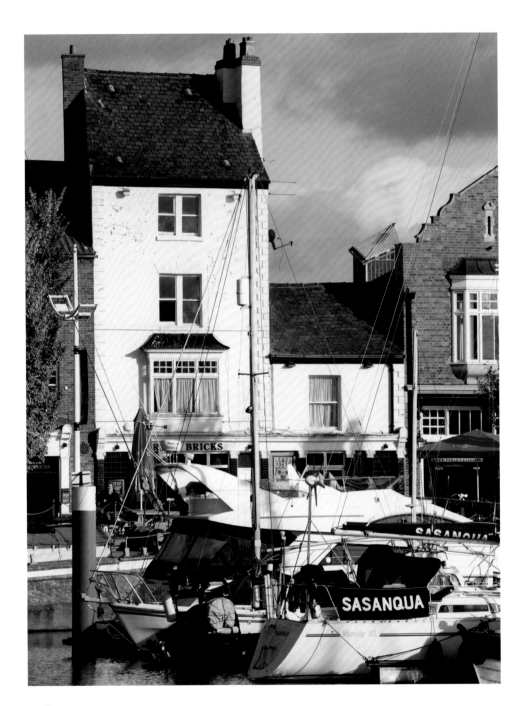

Hull Marina
Hull Marina, looking towards the Green Bricks public house, opened in 1983 on the site of the former Railway Dock and Humber Docks. The marina accomodates 270 berths and hosts the city's jazz and sea shanty festivals. The *Spurn Lightship* is moored in the Marina and serves as a museum.

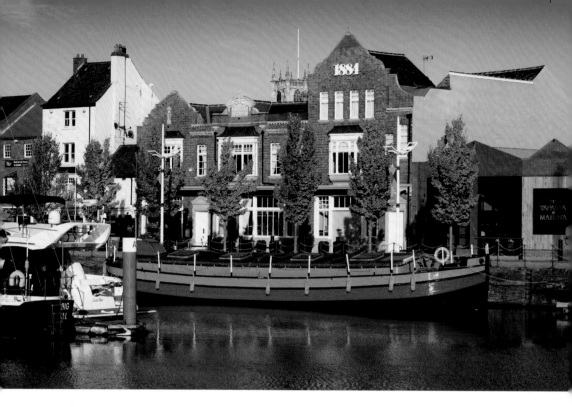

Hull Marina
The marina, looking towards Hessle Gate Buildings and the Green Bricks public house.

Below shows the Marina at dusk.

Hull Marina
The west side of the marina, looking towards the former warehouse No. 13, which is now a restaurant.

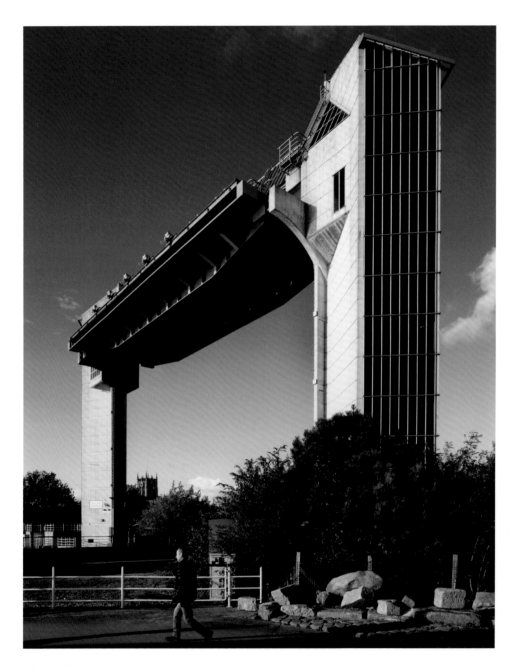

The Tidal Barrier

The tidal barrier spanning the river was constructed in 1980 at the mouth of the River Hull. A massive steel gate, weighing 202 tonnes, can be lowered into the river to seal it from the Humber, preventing tidal surges from moving upriver where they routinely flooded parts of the city and the low-lying areas beyond. The gate is lowered between eight and twelve times a year and protects around 17,000 properties. In 2009, a £10-million upgrade took place, extending the life of the barrier until 2039.

The Former Dock Office
The former Dock Office on Queen Victoria Square, showing a circular window flanked by sculpted figures holding coats of arms. This 1870 Italianate-style building was originally the Dock Office and the home of the Hull Dock Company, which monopolised the whole dock system until 1893. The building is aptly decorated with dolphins and other maritime things. The city council purchased it in 1968. It was converted for use by Hull Maritime Museum, which moved there in 1975 from Pickering Park. The museum was originally established in 1912 as the Museum of Fisheries and Shipping.

Exhibits in the Maritime Museum can be seen below.

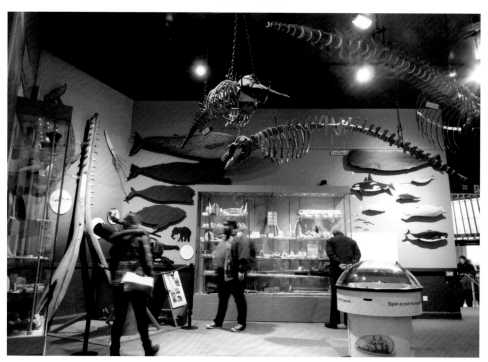

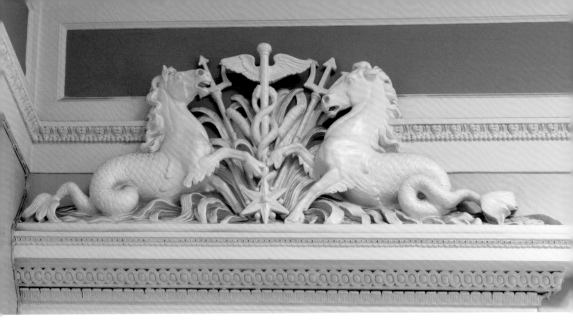

Above: Hull Maritime Museum

Sculpted seahorses above a doorway. Highlights inside the museum include a display depicting the oldest boat remains from the area, the Bronze Age craft from North Ferriby. One gallery focuses on Arctic whaling, which reached its zenith in the 1820s when Hull despatched sixty or more vessels to the Greenland Fishery every season. The gallery features contemporary paintings, ship models, relics, log books and journals.

Below: One of the Truly Iconic Hull Telephone Boxes

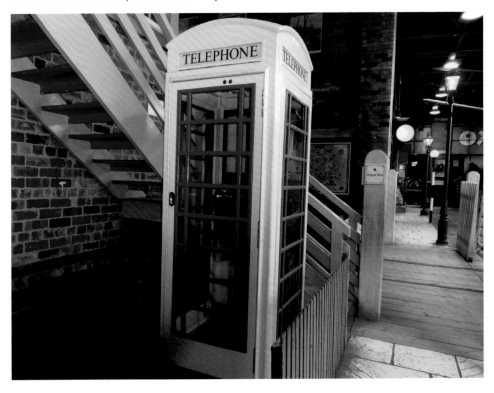

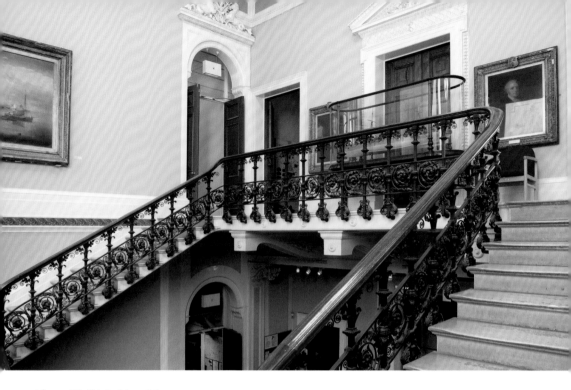

Above: Hull Maritime Museum

There is a skeleton of a whale in the museum, surrounded by harpoons and other whaling paraphernalia. The museum also boasts the largest collection of scrimshaw in Europe. Scrimshaw is the name given to scrollwork, engravings and carvings done in bone or ivory. Whaler folk art contains many examples of scrimshaw, such as decorated whale jawbone, whalebone (baleen), and sperm whale teeth.

Below: The Gilded William II Equestrian Statue

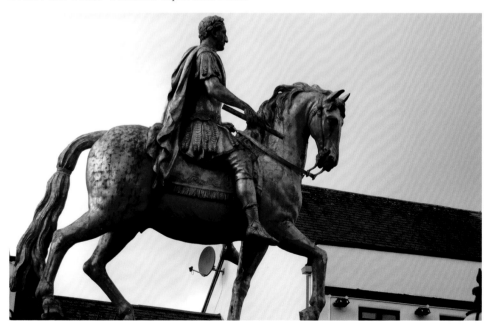

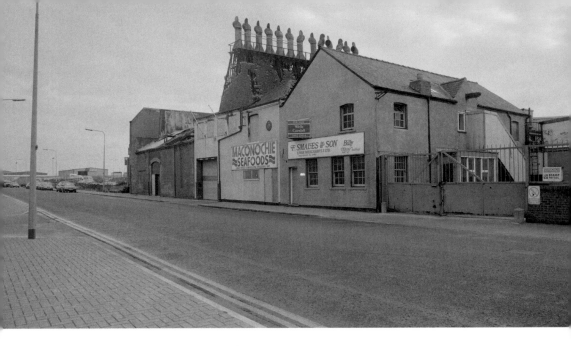

Above: Machonochie Brothers Fish Smoking House
Machonochie Brothers Fish Smoking House, West Dock Street, in 1996. Machonochie Brothers of Fraserburgh had 'Maconochie rations' among its products, which supplied the British Army during the Boer War and the First and Second World Wars.

Below: The Minerva Pub
A long-time oasis for many a Hull fisherman and docker.

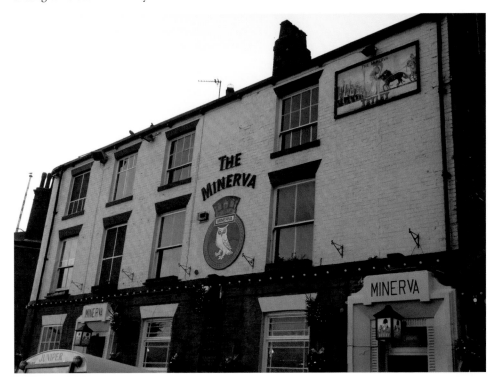

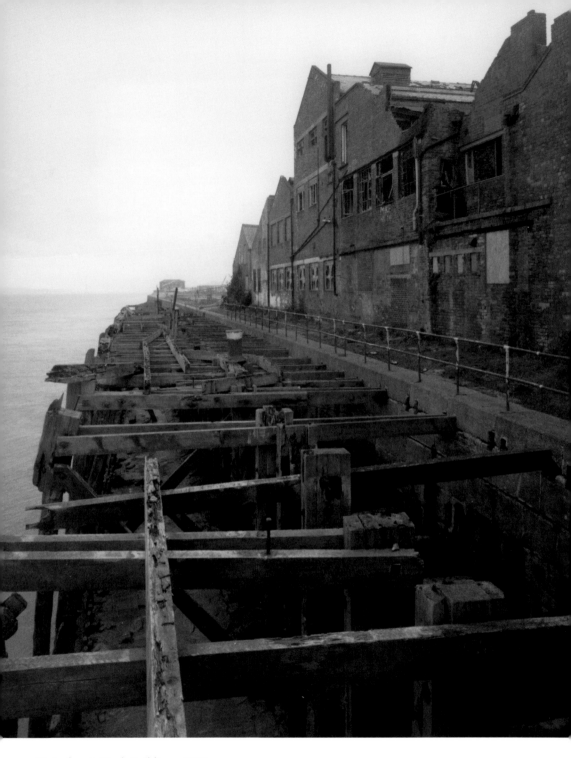

St Andrew's Dock Buildings, 1991
The fishing industry moved to its new home on Albert Dock in 1972 and on 3 November 1975 St Andrew's was closed to shipping. In 1985 the dock was filled in and is now the site of a retail park – St Andrew's Quay.

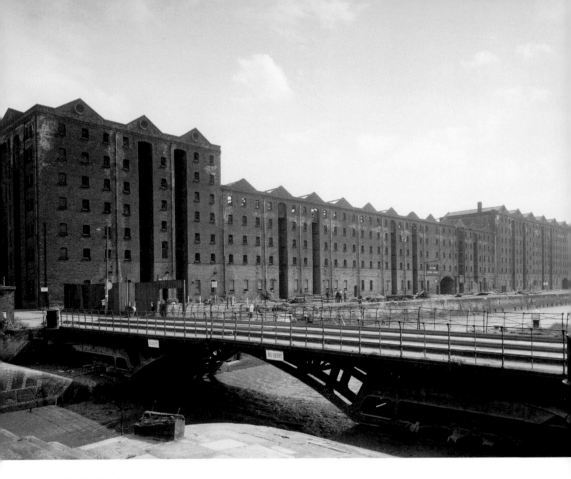

Hull's Docks

The swing bridge and warehouse No. 8 at Prince's Dock in 1972. Opened in 1829 as Junction Dock, it was later renamed Prince's Dock in honour of Prince Albert and the royal visit in 1854. The dock was open for 139 years, closing for shipping in 1968. It was later redeveloped and opened as Princes Quay shopping centre in 1991.

The North Eastern Railway built the No. 1 Oil Jetty at Salt End in 1914 (Salt End Oil Jetties), a mile east of King George Dock. William Wright Dock opened in May 1873, named after the chairman of the Hull Dock Company. The Albert and William Wright docks were amalgamated in 1910. In the late 1950s the Albert Dock was redeveloped. In 1972 the docks were closed to commercial traffic but, due to the fluctuating needs of the fishing industry, they were refurbished, and in November 1975 the docks were again working for the fishing industry.

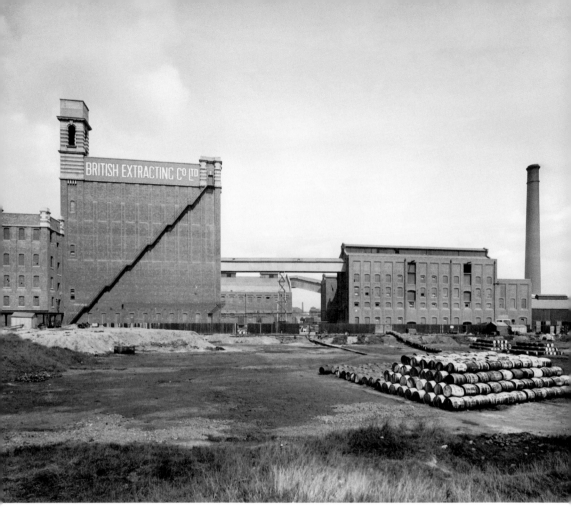

British Extracting Company

A 1920 shot of the British Extracting Co. silo and oil extracting mill on Dalton Street. This site was used for storing oilseeds such as linseed and cottonseed, which were later crushed for their oils and the residue used in cattle meal. In 1915 the British Extracting Co. (a subsidiary of British Oil and Cake Mills) acquired the site of a former brickyard here and began oil-processing operations. The silo and a river in-shipment facility were completed in 1919. The plant was linked to the rail network by a branch line running off the Hull Docks Branch. The production of cooking fat and margarine were the main activities. An extension factory for the production of New Pin Soap opened in 1921, giving serious competition to Lever Brothers. In 1925 Lever Brothers acquired British Oil and Cake Mills, but the factory was closed by 1934.

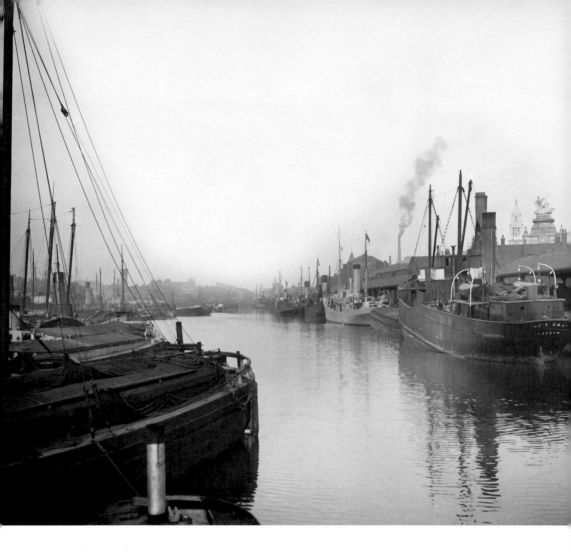

Humber Dock

The Sailors' Orphan Homes Society was formed in 1821 when a meeting was held in the schoolroom at St Mary's Boys' School in Salthouse Lane, initially intended to help veterans of the Napoleonic Wars. The Port of Hull Society for the Religious Instruction to Seamen was thus founded, and a floating chapel, *Valiant*, opened for worship in the Humber Dock. The dock received its first water in 1808, and was formally opened the following year in 1809. Humber Dock closed in 1968 and reopened in 1983 as Hull Marina. The dock, lock, and swing bridge over the lock are now listed. The swing bridge – Wellington Street Bridge – was restored in 2007.

Theatres and Cinemas

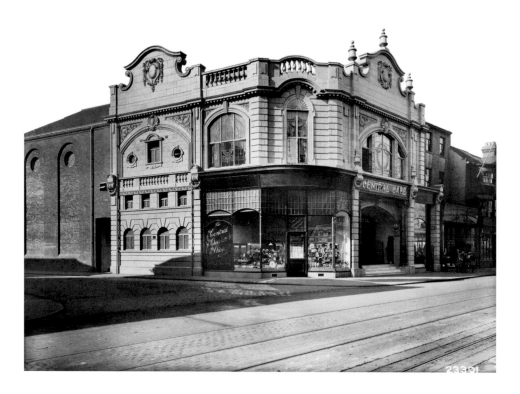

Central Picture Theatre
The Central Picture Theatre of No. 47 Prospect Street is shown here in 1915. Shops in the same building include the Central Café and the Central Chocolate Shop. The building was later renamed the Central Picture House. It was destroyed by bombing in 1941. The nights of 17 and 18 March were bad ones for cinemas in Hull as several were badly damaged, including the National Picture Theatre on Beverley Road. The Alexandra was also destroyed that year, as was the Ritz (formerly the Holderness Road Picturedrome), the Picture Playhouse on Porter Street, the Central in Prospect Street, and the Sherburn in Sherburn Street.

No. 144 Beverley Road

The Swan Inn and the former National Picture Theatre at No. 144 Beverley Road in 2006. It opened in 1914 and was run in conjunction with the Theatre de Luxe on Anlaby Road. At around 10 p.m. on 17 March 1941, the cinema took a direct hit to the rear of the auditorium from an airborne mine. This destroyed most of the building and caused the collapse of the roof. Fortunately, the audience who had, ironically, been watching Charlie Chaplin's *The Great Dictator* reacted to the air-raid warning and assembled in the cinema's foyer – the 150 people all escaped with their lives. What remains is listed – a grand classical façade, behind which are the remains of the foyer, ticket booth, stairways and the rear section of the gallery. The National Picture Theatre is the last surviving ruin of a blitzed civilian building left standing in Britain.

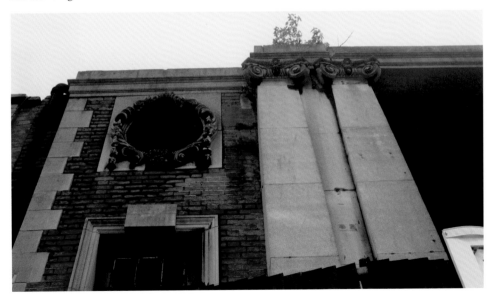

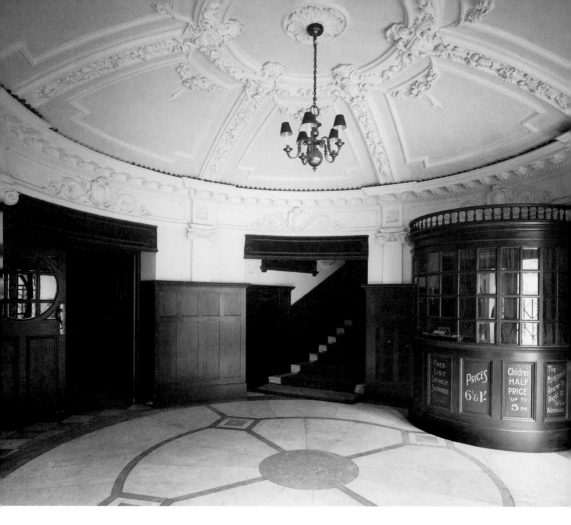

Central Picture Theatre

The vestibule and pay box (ticket kiosk) at the Central Picture Theatre in 1915. Two major air raids took place on the nights of 7 and 8 May 1941 and the Cecil Cinema, the Ritz, and the Alexandra Theatre were destroyed. Also destroyed were the department stores of Hammonds, Edwin Davis, and Thornton-Varley, and the Riverside Quay was destroyed by fire. The Rank Flour Mill took a direct hit, as did the Corporation bus depot and the buildings of the Hull Corporation telephone system. Overall over 400 people were killed, with many more casualties, due to bombs hitting communal bomb shelters.

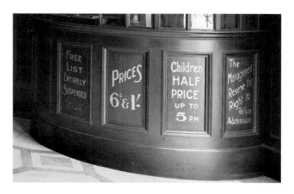

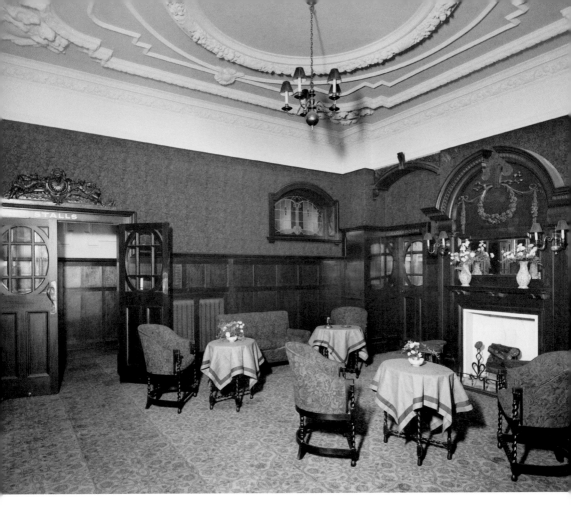

Central Picture Theatre
The foyer at the Central Picture Theatre. The Savoy on Holderness Road was bombed by a
Heinkel 111 on 17 March 1945. Twelve people were killed and twenty-two injured as they
were leaving the theatre after a film. They were the last civilian casualties of the Second World
War to have been injured as a result of a manned aircraft.

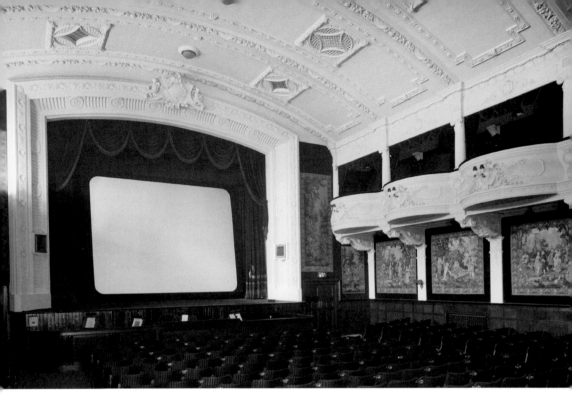

Central Picture Theatre
Two images of the the interior of the Central Picture Theatre. The first is looking towards the proscenium and boxes, with the second showing the café looking towards the fireplace.

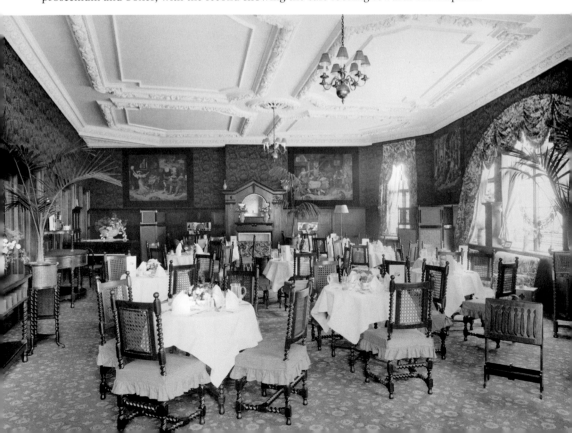

Hull University

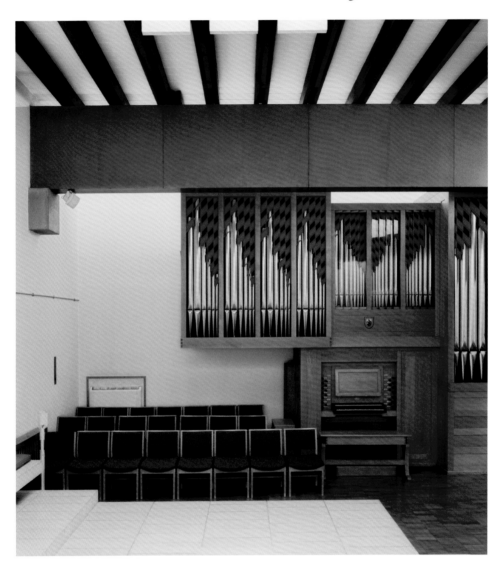

Middleton Hall
The chapel in Middleton Hall at the University of Hull. Middleton Hall reopened in 2016 after a £9.5-million refit, which has transformed it into a world-class cultural venue. The centrepiece is a state-of-the-art 400-seater concert hall, which can be adapted to host theatre productions and surround-sound cinema screenings, all served by the new Arts Café. With industry-standard recording studios and a cutting-edge TV filming and editing suite, the hall also now offers students some of the finest music facilities available. The studios and recording equipment rival the best commercial studios and includes a huge forty-eight-channel mixing desk, along with one of the finest ambisonic studios in the country, which allows listeners to experience 3D sound.

Brynmor Jones Library

The Brynmor Jones Library was completed in 1970 and houses over a million volumes. In 1967 it was named after Sir Brynmor Jones, a pioneer in the research of liquid crystals at Hull, and head of the Department of Chemistry in the 1930s and vice-chancellor of the university from 1956–72.

The library really comprises two main parts: the older art deco entrance and five-floor front section from the 1950s, and the more recent extension, completed in 1970, which comprises eight floors and a basement. Philip Larkin was librarian here from 1955 until his death in 1985.

University College Hull

University College Hull was founded in 1927 with the help of local benefactors, including Thomas Ferens (who gave the land and donated £250,000), G. F. Grant and the city council. The college opened with thirty-nine students and fourteen 'one-man' departments; by 1931 there were 100 students sharing one building – now called the Venn Building. University College Hull was affiliated to the University of London and offered courses in the arts and pure sciences. The college won its independence in 1954 when the University of Hull became a separate institution with the right to award its own degrees – it was Yorkshire's third university and England's fourteenth. In 1956 the student population topped 1,000 for the first time.

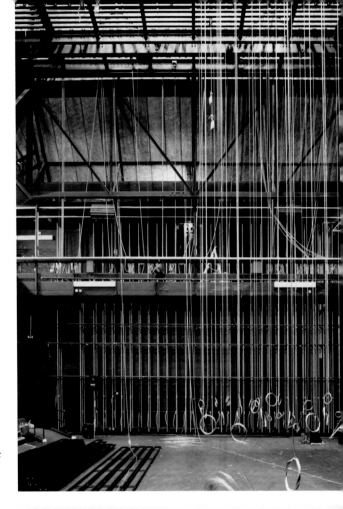

Donald Roy Theatre,
Gulbenkian Centre
Electrical cables hanging in the
Donald Roy Theatre within
the Gulbenkian Centre. Below
is a shot of the exterior of the
Gulbenkian Centre. The Donald
Roy Theatre and the the Anthony
Minghella Studio make up the
Centre. The University of Hull
drama department under Donald
Roy admitted its first students in
1963, making it the third drama
department in the country after
Bristol and Manchester. It was,
however, the first UK university to
have a purpose-built drama studio
for its students to learn all aspects of
technical stage presentation, as well
as television and radio acting.

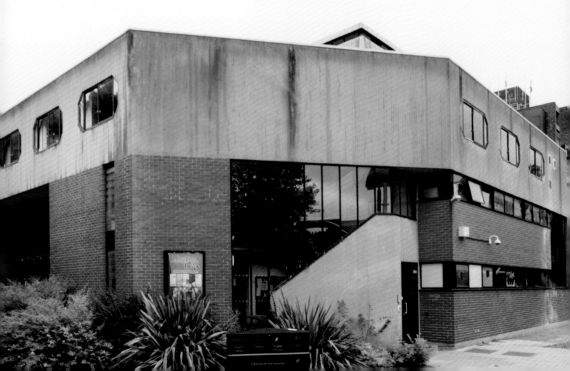

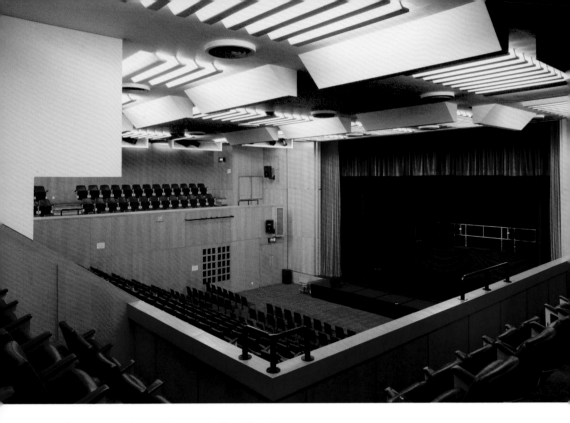

Above: Donald Roy Theatre, Gulbenkian Centre
An inside view of the theatre, looking down at the stage from a corner of the gallery. The television studio has been converted into the Anthony Mingella Studio containing a production office, seminar room, prop store and a computer suite. A fully functioning box office has also been introduced at the rear of the foyer.

Below: The Larkin Building
This image shows the Larkin Building, looking towards Middleton Hall.

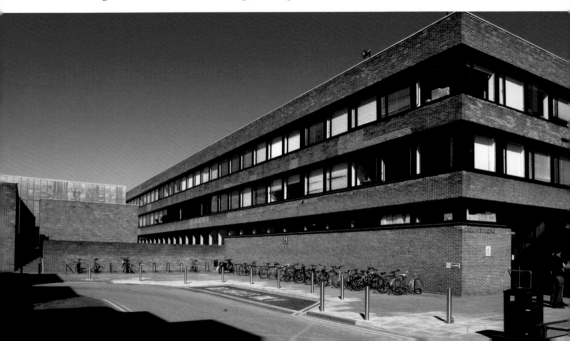

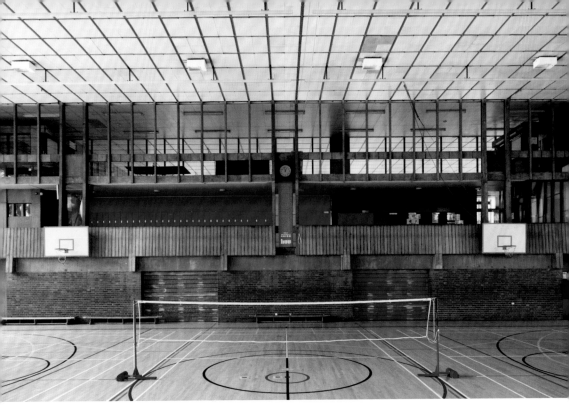

Hull University Sports and Fitness Centre
The university's sports facilities receive around 2,000 visits a week, including visits from the local community, youth sport clubs, and regional and national amateur and professional sport teams.

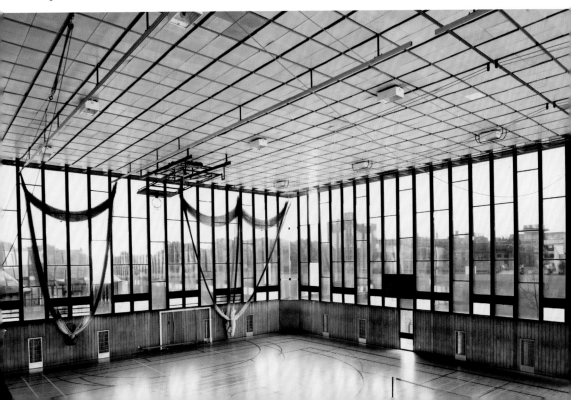

University of Hull Business School
The University of Hull Business School was established in August 1999. It now has 3,500 students from over 100 countries. The Logistics Institute was completed in September 2007, and officially launched in March 2008.

The image below looks from the university Business School towards Derwent House.

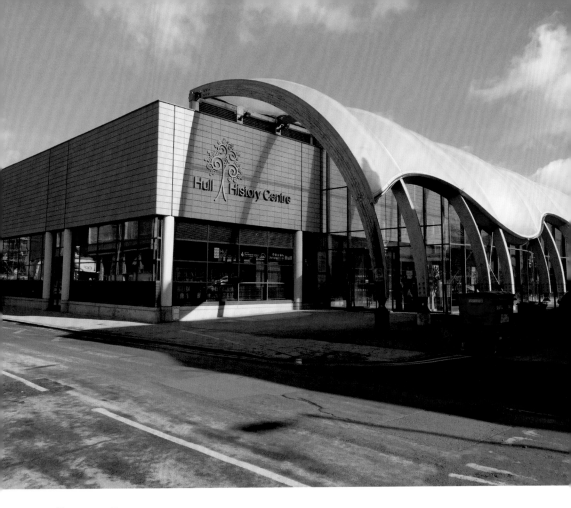

Hull History Centre

Hull History Centre in the city centre uniquely draws together the collections of the Hull City Archives, the University of Hull archives and the Local Studies Library. Hull is the first city in the UK to unite local council and university collections under one roof. If you were to line up the collections (books and journals, magazines, maps, paintings, photographs, pamphlets and film), they would extend across the 2,220-metre-long Humber Bridge four times.

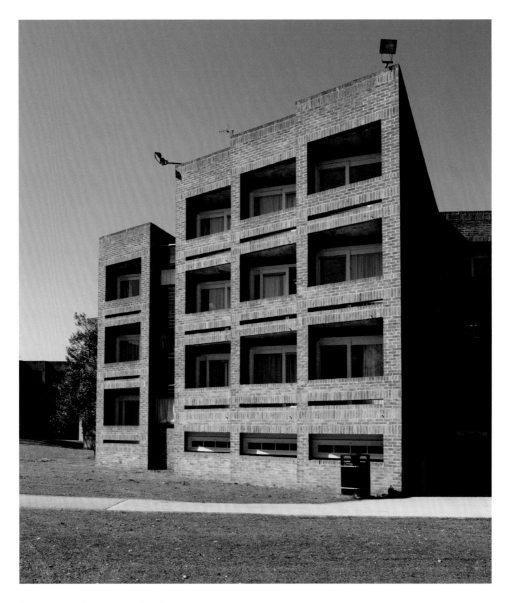

Grant Hall, the Lawns, Cottingham

The Lawns, in leafy Cottingham, is where close on 1,000 University of Hull students live. It comprises seven halls of residence (Ferens, Lambert, Nicholson, Morgan, Downs, Reckitt and Grant) and the Lawns Centre – the catering and social hub. The halls are set in 40 acres of 'landscaped parkland'. Ferens Hall, built in 1957, accommodates 191 students all in single rooms; it was established in the 1950s as a male-only hall of residence in a traditional rectangular style with rooms around three sides of a central lawn. All the other award-winning halls were designed by Gillespie, Kidd and Coia, and comprise five blocks accommodating 140 or so residents. A typical block consists of three floors, with each floor housing nine students in seven rooms. Originally, all the halls were either male or female; from 1985 they all became mixed.

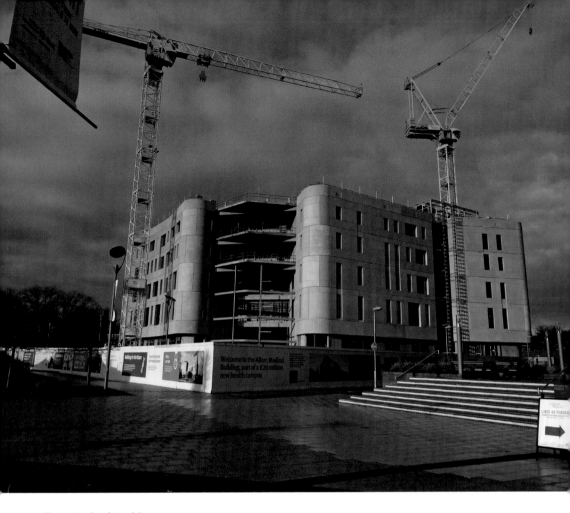

Allam Medical Building

The centrepiece of the university's state-of-the-art, £28-million world-class Health Campus is the five-storey Allam Medical Building, which will soon accommodate the Hull York Medical School. It will feature a mock hospital ward, operating theatre and intensive care facilities, as well as research space. The building, which has received £7 million from Dr Assem Allam, chairman of Hull City FC, will also house a large lecture theatre and a ground-floor atrium and café. In addition to the Hull York Medical School, the campus will include faculties for health and social care, sport, health and exercise, and science, and establish a new Institute for Clinical and Applied Health Research.

Above: Wilberforce Building

The Wilberforce Building has recently undergone a substantial refurbishment. The £2.65-million programme is the second phase of redevelopment at the site, which houses departments such as the Law School, Politics and International Studies, and the Centre for Educational Studies.

Below: Hull University Union, 2017

Hull University Union, shown here in 2017, is famous for its Beirut hostage John McCarthy Bar. He and Jill Morell – his lifeline and champion back in London, and founder of 'Friends of John McCarthy' (FOJM) – were both graduates of the university. Other alumni include Mike Stock (of Stock, Aitken & Waterman); the musicians Tracey Thorn and Ben Watt (Everything But The Girl); film director Anthony Minghella; poet Roger McGough; TV presenter Sarah Greene (*Blue Peter*, *Going Live*); the Labour politicians John Prescott, Frank Field, and Roy Hattersley; Jenni Murray of *Woman's Hour*; and Radio 1 presenter Mark Chapman.

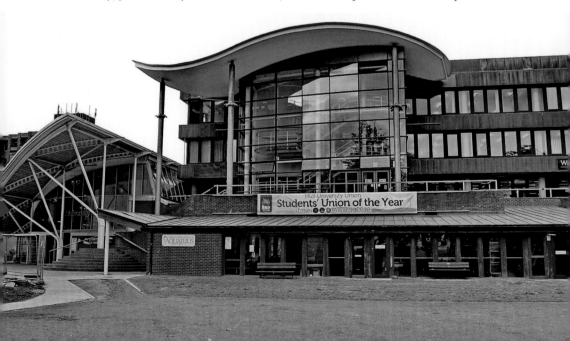

The Deep

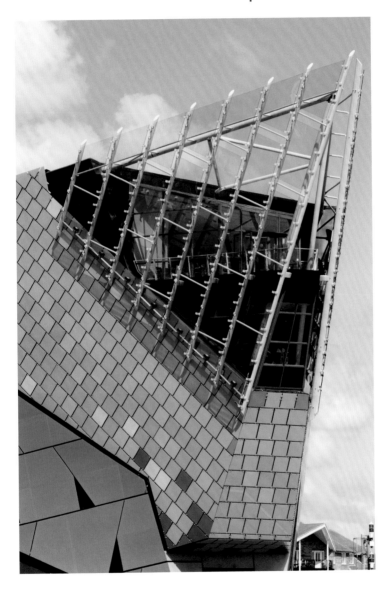

The Deep, Tower Street, Sammy's Point

The Deep is by common consent one of the world's best and most spectacular aquariums. No fewer than 3,500 fish can be seen swimming about here, including seven magnificent species of sharks, rays and northern Europe's only pair of green sawfish, along with fish that glow in the dark, coral, turtles, jellyfish, frogs, penguins, a flooded Amazon forest, and numerous species of insects. Marine life aside, the tanks contain 2.5 million litres of water and 87 tonnes of salt. The Deep is the world's only submarium – a building that is partly submerged in the water that surrounds it.

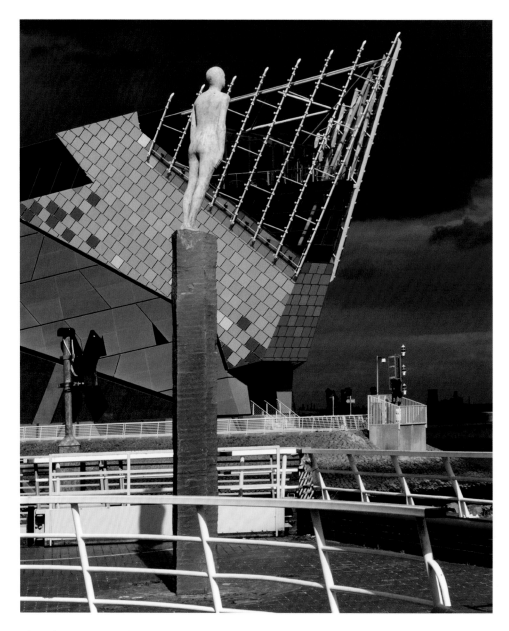

The Observation Deck
A view from 2011 of the aquarium building's observation deck from the west, with the sculpture *Voyage* by Steinunn Thorarinsdottir in the foreground. This architectural phenomenon is at Sammy's Point, which overlooks the Humber Estuary and its confluence with the River Hull. It was designed by the world-famous architects Sir Terry Farrell & Partners, and opened in 2002. Other Farrell projects include the MI6 building; KK100 in Shenzhen, the tallest building ever designed by a British architect; Beijing South railway station, at one time the largest railway station in Asia; Charing Cross station; the new headquarters for the Home Office and the conversion of the Grade I-listed Royal Institution of Great Britain.

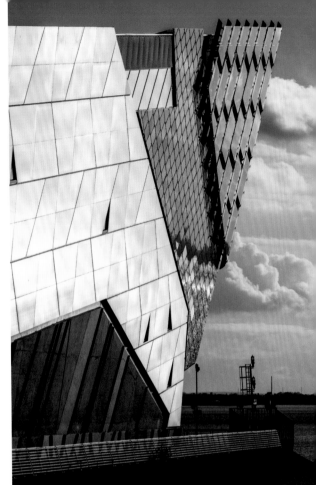

Research at the Deep
The Deep is also a cutting-edge centre for marine research. The marine biologists here not only look after the animals in the Deep's collection but conduct research into the marine environment as well. Their work, in association with the University of Hull, extends from protecting endangered penguins in Antarctica to monitoring manta ray populations in the Red Sea.

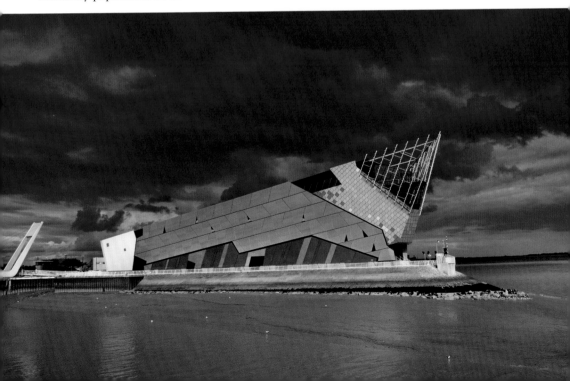

Shops and Pubs

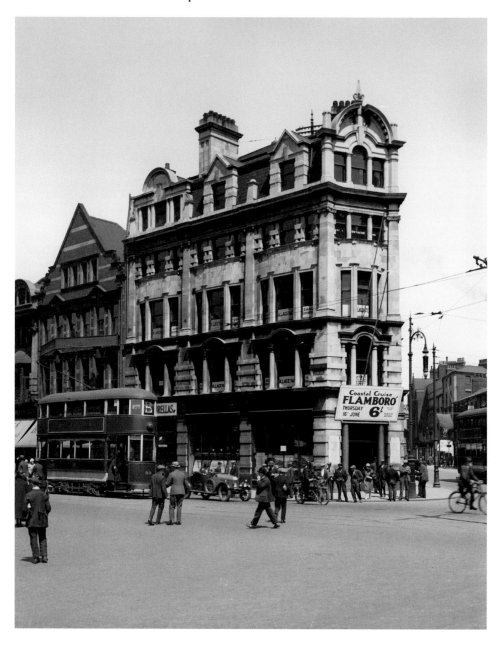

King Edward Street and Savile Street
A 1927 photo of Nos 2–4 King Edward Street and Savile Street, with the London Midland Scottish Railway office on the ground floor of the five-storey building behind.

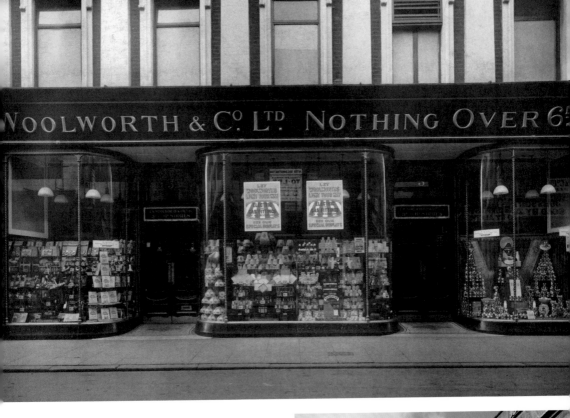

Whitefriargate
Above: F. W. Woolworth and Co. Ltd at
Nos 4–5 Whitefriargate.

Right: Marks & Spencer, Nos 40–43
Whitefriargate, in 2010.

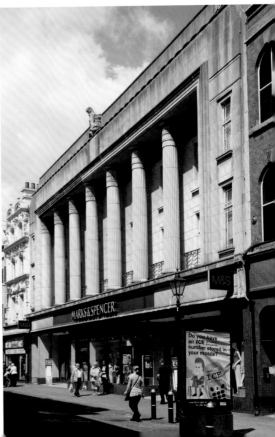

High Street

This image looks north-east along High Street from outside Ye Olde Black Boy pub. An advertising leaflet printed for Warwick & Co. (Hull) Ltd between 1923 and 1925 tells us:

This house in bygone days was a regular meeting house for merchants and others. Messrs. Warwick & Ward (Hull) Ltd., wish to intimate to those concerned, that facilities for meeting there still exist. The bar downstairs retains its old characteristics, and one can sit there at ease in cheerful comfort surrounded by highly polished hogsheads and glistening bottles. Two rooms upstairs are available for small business meetings. The rooms are fully equipped for these purposes, and whilst they are part of the old inn, they have a separate entrance, and it is not necessary to pass through the bar to gain admittance to them. Situated in the heart of Hull's business community, they form an ideal place of meeting. Anyone desirous of arranging small meetings is invited to make application to the Manager for the use of these rooms. Liquid refreshments can be served in them during licensed hours.

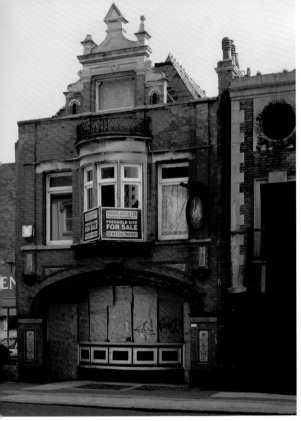

The Swan Inn, Beverley Road, 2006
A decorative corbel and pilaster on the front of the Swan Inn, Beverley Road (top right), and tiling surrounding a decorative motif on the front of the pub (bottom left). In February 2015, Denise Nelson commented, 'This pub closed for good in September 2003. I was the last licensee, if anyone believes in ghosts they should spend some time in it and hear the little girl shouting for her mammy, and telling people to get out. Very scary.'

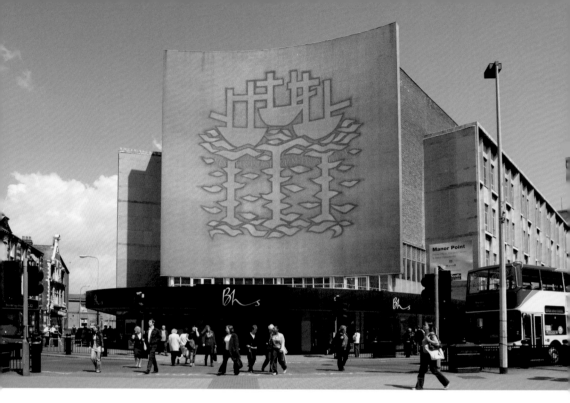

Jameson Street and Beverley Road
Above: The former British Home Stores at Nos 32–38 Jameson Street.

Below: Looking north along Beverley Road, towards the former National Picture Theatre.

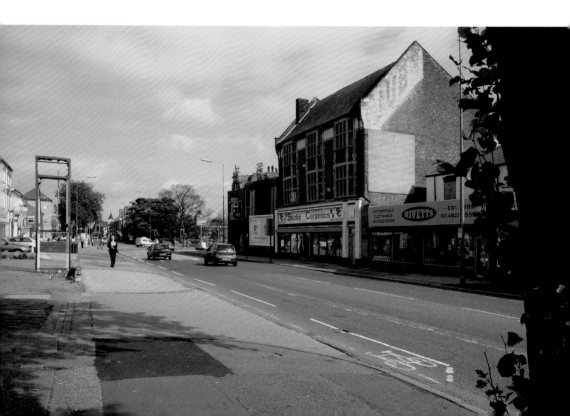

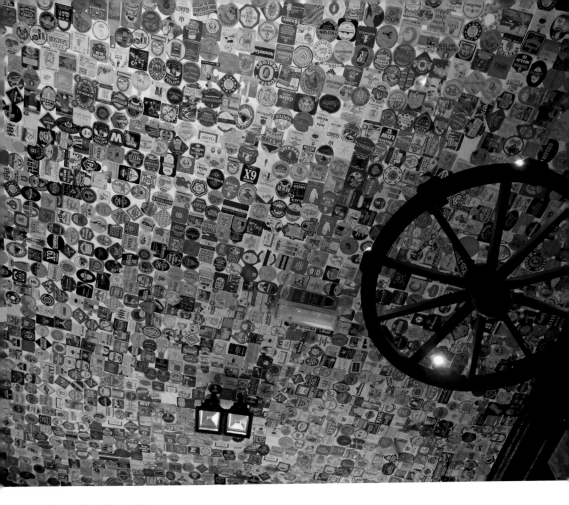

Above: The Lion & Key
The ceiling of the Lion & Key in Hull's old town.

Below: Annison's Corner
Annison's Corner at Nos 119–127 Witham.

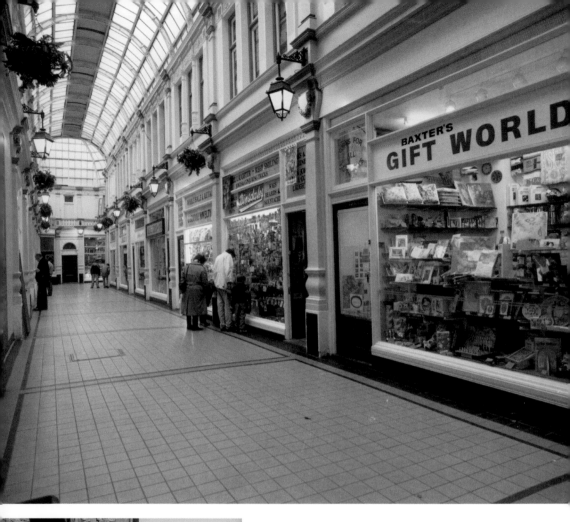

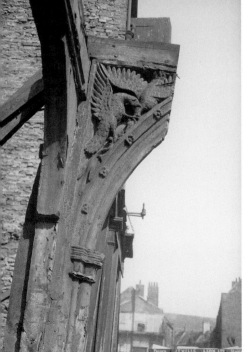

Central Buildings
Above: Hepworths Arcade, Market Place, in October 1991.

Left: Detail of the carved south face of the spandrel on the right-hand post outside the Old George Inn on the High Street in 1945.

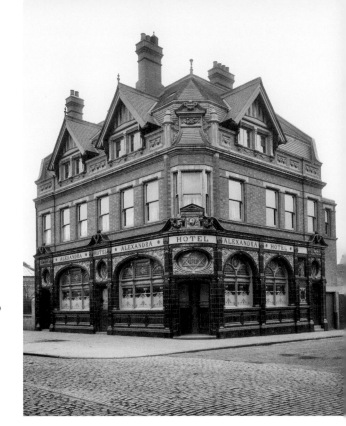

Alexandra Hotel
Right: The Alexandra Hotel at No. 69 Hessle Road in 1896. Burmantofts & Co. of Leeds manufactured the ornate terracotta and ceramic finishes on the building's façade.

Below: The magnificent façade of The Empress in Alfred Gelder Street.

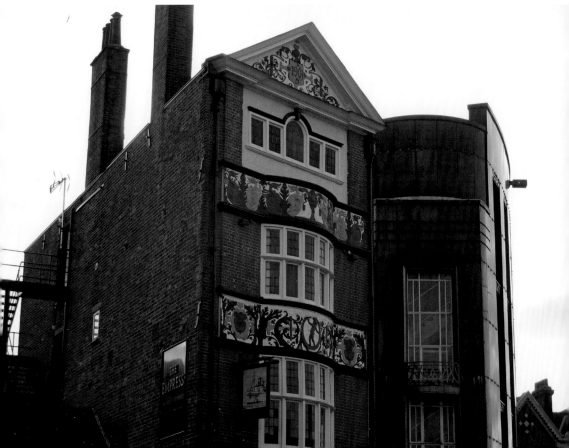

About the Archive

Many of the images in this volume come from the Historic England Archive, which holds over 12 million photographs, drawings, plans and documents covering England's archaeology, architecture, social and local history.

The photographic collections include prints from the earliest days of photography to today's high-resolution digital images. Subjects range from Neolithic flint mines and medieval churches to art deco cinemas and 1980s shopping centres. The collection is a vivid record both of buildings that are still part of everyday life – places of work, leisure and worship – and those lost long ago, surviving only in fragile prints or glass-plate negatives.

Six million aerial photographs offer a unique and fascinating view of the transformation of England's towns, cities, coast and countryside from 1919 onwards. Highlights include the pioneering photography of Aerofilms, and the comprehensive survey of England captured by the RAF after the Second World War.

Plans, drawings and reports provide further context and reconstruction artworks bring archaeological sites and historic buildings to life.

The collections are housed in a purpose-built environmentally controlled store in Swindon, which provides the best conditions to preserve archive items for future generations to enjoy. You can search our catalogue online, see and buy copies of our images, as well as visiting our public search room by appointment.

Find out more about us at HistoricEngland.org.uk/Photos
email: archive@historicengland.org.uk
tel.: 01793 414600

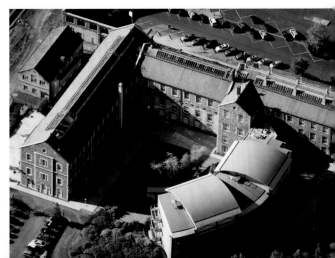

The Historic England
offices and archive store in
Swindon from the air, 2007.